DEL ◆ MAR

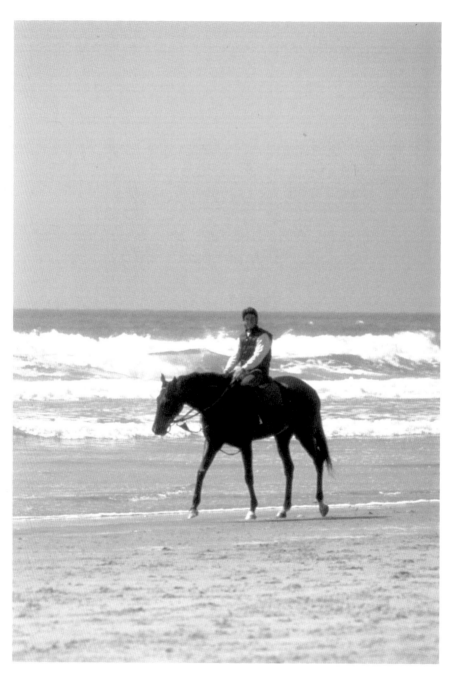

A thoroughbred and rider enjoy a walk on the beach at Del Mar. *Courtesy DMTC.*

DEL · MAR

◆◆◆◆◆◆◆◆◆◆◆◆◆◆◆◆◆◆◆◆

WHERE THE TURF MEETS THE SURF

by HANK WESCH

THE
History
PRESS

Published by The History Press
Charleston, SC 29403
www.historypress.net

First published 2011
Second printing 2012

Manufactured in the United States

ISBN 978.1.60949.310.3

Library of Congress Cataloging-in-Publication Data

Wesch, Hank.
Del Mar : where the turf meets the surf / Hank Wesch.
p. cm.
Includes index.
ISBN 978-1-60949-310-3
1. Del Mar Racetrack (Del Mar, Calif.)--History. I. Title.
SF324.35.C2W47 2011
798.4009794'98--dc23
2011016278

Contents

Contents

Acknowledgements

I would like to thank the following for helping to make this work possible:
The *San Diego Union-Tribune*, specifically newsroom operations manager Nancy Wyld, for permission to reproduce work written as a *Union-Tribune* staffer covering Del Mar from 1985 to 2010 and all the editors and colleagues in the *UT* sports department who provided advice, encouragement and support in the production of those stories throughout the years.

Dan Smith, Mac McBride, Mary Shepardson and others at the Del Mar Thoroughbred Club for assistance with the images, records and lore of the track in early 2011 while working on the book proper and for support and encouragement over the twenty-five previous summers.

The editors at The History Press for calling on me and making it happen.

My family—especially my wife, Pat—for encouraging me to take on this project and providing support throughout. My friend Bill Nack, who went from newspaper guy to book author with *Secretariat* and agreed with the family that I should "Go for it."

Prologue
One Special Weekend

August 13–15, 2010

In my mind, the purely distilled essence of Del Mar, the racetrack and the experience to be had there seven weeks every summer, was on display at opposite ends of the country the weekend of August 13–15, 2010.

On August 13, at Saratoga Springs in upstate New York, the trio of Azeri, Best Pal and Don Pierce was inducted into the National Museum of Racing and Hall of Fame. Azeri and Best Pal were two of the best horses I'd closely covered in my quarter century as a turf writer, initially for the morning *San Diego Union* and then for the *Union-Tribune* after the 1992 merger with the afternoon paper. Their induction into the Hall of Fame supported my opinion that they were the most strongly San Diego–connected female and male thoroughbreds to achieve greatness.

Don Pierce, who had been a worthy competitor for Bill Shoemaker on the track and a good friend off it for many years, had always been a go-to source for me for a quote or comment when the story involved people or events at Del Mar in the decades before I'd come on the scene.

I knew their stories, had written a lot about them myself and was glad to see and hear them retold on the Hall of Fame telecast.

It was the choice of trainer Laura de Seroux to condition the talented filly Azeri in the tranquil setting of the San Luis Rey Downs Center in the hamlet of Bonsall, twenty miles north of Del Mar, rather than at the tracks that were the venues for her major races.

From March 2002 to August 2003, Azeri prepared at San Luis Rey; would ship to Santa Anita, Hollywood Park and Del Mar in Southern California,

Jockey Don Pierce, a regular Del Mar rider from the late '40s through the '60s and afterward a Del Mar resident, was inducted into horse racing's Hall of Fame in 2010. *Courtesy Del Mar Thoroughbred Club (DMTC).*

Oaklawn Park in Hot Springs, Arkansas, and Arlington Park in Chicago; and would win eleven straight Grade I or Grade II races. The one in the Breeders' Cup Distaff at Arlington Park in October 2002 was the lynchpin for Azeri being voted Horse of the Year for 2002, making her only the third female accorded the honor and Seroux the first female to train such a champion.

Best Pal was born in 1988 about thirty miles from the Del Mar track at the Golden Eagle Farm, in Ramona, of John and Betty Mabee, the first couple of racing in San Diego, the patron and matron of the Del Mar Thoroughbred Club for nearly three decades. Growthy and of an ornery temperament, Best Pal was gelded early on "because we wanted him to be a racehorse," John Mabee said. And what a racehorse he turned out to be.

Best Pal's eighteen victories from 1990 to 1995 included the Del Mar Futurity and Hollywood Futurity as a two-year-old; Swaps Stakes at Santa Anita and the inaugural Pacific Classic at Del Mar as a three-year-old; and the Santa Anita Handicap and Hollywood Gold Cup as an older horse.

Best Pal was the first and finest in a line of Golden Eagle color bearers that made the Mabees winners of Eclipse Awards as national champion breeders in 1991, 1997 and 1998 and the leading owners for the Del Mar meeting six times from 1990 to 1999.

"A lot of people don't realize we didn't go out and buy runners, we bred and raised runners," Larry Mabee said of his late parents at the Hall of Fame ceremony. "This represents what the family did for the sport. We raced what we bred."

Larry broke up a little saying that at Saratoga, and back home in San Diego, so did I.

Pierce, the son of a mechanic who worked on logging trucks, spent his youth in rural America, from Oklahoma and the greater Southwest to the Pacific Northwest. Like most in his profession, he started riding at a very young age in very obscure places. And the learn-by-doing method prepared him to win his first race at a track with parimutuel racing, aboard Supplier at Ruidoso Downs in New Mexico on June 13, 1954.

Del Mar wasn't always Pierce's choice for a summer race meeting. He opted for Saratoga in the early 1960s, and his one Del Mar riding title came in 1966 after six years away. But Pierce won fifty-four stakes races at Del Mar between 1958 and 1981, a total that still ranks twelfth on the track's all-time list, and settled down in the area upon his retirement.

There were times when it seemed Pierce wasn't destined for a place in the Hall of Fame, which made it sweeter for his supporters when it was announced that the Hall of Fame's Historic Review Committee had bestowed on him the honor.

Back at Del Mar, one day after the Hall of Fame inductions at Saratoga, the La Jolla Handicap was won by Sidney's Candy, owned by weight-loss company founder Jenny Craig of Del Mar and named in honor of her late husband, Sid. The race was won in course record time for one and one-sixteenth miles in Sidney's Candy's first run on turf.

The announced on-track attendance total was 38,577, a number to create envy from managers of tracks across the country and irritate old school horseplayers actually on the scene—envy because on-track numbers one-third that big are commonplace, even on weekends at most tracks; irritation for those stuck with the timeworn thought that horses, riders and betting windows on their own should create the kind of interest they used to.

The biggest drawing card of the day wasn't Santa Anita Derby winner and Kentucky Derby contender Sidney's Candy. It was a Reggae Fest concert on the infield featuring Jimmy Cliff. But under Del Mar policy, those entering the gates prior to the final race are admitted for the general admission price of six dollars or can purchase a track membership, which trims the price to three dollars. Arrive after the last race and it's twenty dollars to enter. So a much younger and energetic crowd than could be found at virtually any other track was exposed to thoroughbred racing for a time, however briefly.

And, who knows, maybe the experience of listening to the Jamaican beats and viewing another typically sparkling California sunset will make some of them want to come back.

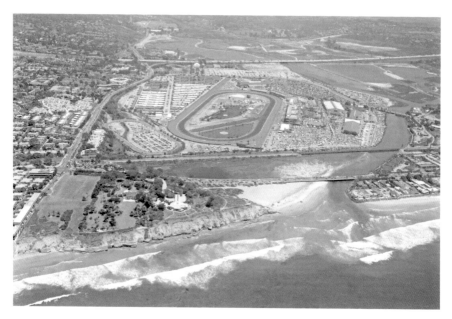

An aerial view of the track and its surroundings. *Courtesy DMTC.*

On Sunday, Del Mar presented the John C. Mabee Stakes. A crowd of 18,036 was on hand to see Wasted Tears, vanned in from Texas by breeder/trainer Bart B. Evans, win the Grade II event out of a stall made available in the barn of Hall of Fame trainer Richard Mandella.

Here are some points about Del Mar that the weekend hammered home, at least to me.

Del Mar has, as much as any track in North America and a lot more than most, exhibited the ability to advance with the times while being true to its colorful-from-the-start beginnings—to stay cool and comfortable in its own skin according to the style personified by track co-founder Bing Crosby in 1937. And, most importantly, in the first decade of the twenty-first century, Del Mar has managed to remain significant and relevant—locally, regionally, nationally and especially economically—at a time when many racing emporiums, both the storied and the small, appeared to be fighting a losing battle.

2000–2010

ZENYATTA 1-2-3

Trainer John Shirreffs was not a big fan of the synthetic, engineered or all-weather racing surfaces mandated by the California Horse Racing Board for major tracks in the state starting in 2008.

It was like running horses on Velcro, he once said, meaning there was too much stick and not enough slide when the metal shoes of thousand-pound thoroughbreds hit the stuff in full racing mode. Shirreffs wasn't a huge fan, by any brand name, of the mix of silica sand, fibers, rubber and wax that had replaced good old dirt in the Golden State.

But he always seemed most content with the Cushion Track surface at Hollywood Park in Inglewood, where his stable—and eventually the world's—star Zenyatta was headquartered. And Shirreffs was especially wary of the Polytrack version at Del Mar.

He deliberated the options after all three of Zenyatta's victories in the Vanity Handicap at Hollywood Park. Make the 120-mile trip down the 405/5 Freeway to San Diego County for the Clement L. Hirsch Stakes about a month after the Vanity. Or go elsewhere.

And Del Mar went three for three.

"It depends on the track at Del Mar and what they've done with their [second-year surface]," Shirreffs said following the 2008 Vanity in which Zenyatta set her career record at 6-0. "That's where she's going. She's shipping to Del Mar."

In 2009, wins by Rachel Alexandra in the Mother Goose Stakes at Belmont Park in New York and Zenyatta in the Vanity on June 27 promoted

the possibility of a matchup between the two later that summer. But the unqualified aversion to synthetic surfaces stated by Rachel Alexandra owner Jess Jackson meant that if the fantastic females were to meet, it would have to be somewhere other than Del Mar.

That, and the fact that the Breeders' Cup would be staged on Santa Anita's synthetic in the fall, was the decider.

"The next race will probably be at Del Mar," Shirreffs said after a Vanity that made Zenyatta 11-0.

In 2010, Zenyatta went into the Vanity looking for a seventeenth straight victory that would top the records of Citation and Cigar. With the $5 million Breeders' Cup Classic, a race Zenyatta had won the previous fall at Santa Anita in competition against world-class male runners, set for Churchill Downs in November, speculation was that Team Zenyatta—owners Jerry and Ann Moss, their racing manager and Shirreffs's wife, Dottie Ingordo Shirreffs, and jockey Mike Smith—were poised to showcase their crowd-pleaser east of the Mississippi for the first time that summer.

But Shirreffs ended the speculation days before the Vanity, saying that Zenyatta would remain at Hollywood Park and train there until days before the Hirsch, then ship to Del Mar for the race. Depending, of course, on surface conditions.

2008

Zenyatta let seven rivals array themselves in front of her soon after the start and then passed them all in rolling a seven the easy way.

The one-length victory was the seventh to open her career, and anyone who wasn't impressed with Zenyatta couldn't have been watching the race. The time of 1:41.48 was the fastest for one and one-sixteenth miles in the two years of a Polytrack main surface, bettering by .09 seconds that of Well Armed in the males-only San Diego Handicap two weeks earlier.

"Her last race [Vanity] was one of her 'C' races," Smith said. "She didn't run that well, but she still got it done. That's what the good ones do. Today was one of her 'A' races. They [other riders] all know her, she's such a great big target you can't miss her. And they all rode to beat her. But it was fair and square, and it was classy."

In keeping with her racing style, Zenyatta was content to trail for a first quarter run in 0:23.34 set by Silver Z. Smith was content to keep Zenyatta

off the rail most of the way down the backstretch, even as other riders made room along the rail. It was a potential trap, as Smith well knew.

"They were doing the best they could to try and help their horses win and trying to beat her," Smith said.

Zenyatta moved smoothly into and through the trap and came out running when the field straightened for the stretch run.

"I only touched her once or twice on the turn," Smith said. "She gives you that power. I don't want to move my hands too much, just let her roll."

Zenyatta bounded past Model, a twenty-nine-to-one shot that had taken the lead at the top of the stretch, with a sixteenth of a mile to go and crossed under the wire geared down, with Smith as still as a statue in the saddle.

"I know she set a track record, but if I'd have let her go, no telling what she might have done," Smith said. "She was just galloping."

2009

In the post parade before the race, Zenyatta started affecting a stiff-legged walk with her front legs.

It was something, Shirreffs would say, the great mare had recently taken to doing. As a form of both self-expression and communication to the fans, who were taking to her in ever-increasing numbers and zeal, Zenyatta would, of course, take it to an art form in the eight later races of her career.

That afternoon at Del Mar, what looked like something for the show ring was actually an equine athlete preparing to put on a show.

"You don't need to warm her up, she gets herself ready doing that," Smith said. "She stretches and dances."

Before the race, while her seven rivals jogged around the turn and along the backstretch to prepare for the one-and-one-sixteenth-mile run, Zenyatta stood still at the quarter pole, taking in the overall scene.

"John tells me where to take her to stand her after the post parade, and it works," Smith said. "We'll just keep doing it."

From before the race to a finish that had an on-track crowd of 20,335 stirred to the core to a post-race vignette in which Smith brought Zenyatta back to pose before the large infield video screen—looking for all the world like she was checking out her $2.40 win price—Zenyatta showed how different, special and fascinating a champion racehorse can be.

To borrow a phrase from a country music hit of the time: "She's got whatever 'it' is."

Last in the field of seven through a dawdling 1:13.64, Zenyatta went to work for a sensational estimated final quarter of 0:22.49 seconds and crossed under the finish line at her peak speed of the race—forty miles per hour, according to the Trakus timing system.

Zenyatta hit the wire a head in front of twenty-two-to-one shot Anabaa's Creation to extend her winning streak to 12-0. It was the closest finish of all Zenyatta's eventual nineteen career victories. But Zenyatta's connections were not among those who thought the streak was over when considering the ground to be made up in the deep stretch.

"I always feel that a horse that can repeat performances like she does in Grade I races against very high-level horses is just amazing, and she's never faltered one time," Shirreffs said. "Any time she goes out in a race, she wins."

Smith confessed to a small amount of pilot error but maintained supreme faith in Zenyatta.

"I certainly underestimated the competition," Smith said. "Life Is Sweet was in there, and I was just going to track her, and when she made her move, I was going to make mine. But then I looked up and the competition had gotten away from both of us. I just kind of flagged [Zenyatta] with the stick, and she started hitting that stride."

Zenyatta and Smith moved from seventh to fourth, taking a wide path around the turn, but still had 4½ lengths to make up in the relatively short home stretch.

"That last quarter mile was freaky," Smith said. "I felt like I was on a quarter horse coming out of the gate. Great horses always find a way no matter what is stacked up against them and that's what she did…She was just kind of having fun down the stretch with her ears pricked [a sign of a stress-free horse]. The incredible thing was that when I stood up past the wire, she hit another gear and galloped out like a machine."

The finish was close enough that Tyler Baze, on Anabaa's Creation, said afterward that he thought they had won. But the defeat was not hard to accept.

"We got beat by a champion," Baze said. "I didn't know where Zenyatta was, but I knew she was coming, and she just got us."

Shirreffs, age sixty-four, who had seen some tremendous equine feats in thirty years as a trainer, marveled at the wonder in his charge.

"Isn't it amazing how she just lengthens her stride and the farther down the stretch she goes, the faster she gets going," Shirreffs said. "It's really something to see. Some horses pick their head up as they get near the wire; Zenyatta's head goes down, and she just lengthens her stride."

2010

The final part of Zenyatta's Del Mar trilogy came perilously close to not happening because of issues with the Polytrack surface. As Ed Zieralski wrote in the *San Diego Union-Tribune* the following day, "The drama played out over a few hours early [in the] morning as Shirreffs, his exercise rider Steve Willard and others in Team Zenyatta fretted about the condition of the Polytrack."

In a repeat of what had happened a month earlier following a hugely successful opening day of the meeting, some of the materials that compose the surface had separated, and track superintendent Richard Tedesco had to do some timely work as a remix master to save the day and Del Mar's reputation.

"That was Tedesco, huddling with Shirreffs, his friend since Shirreffs was a groom, assuring him the track would be fine by post time," Zieralski wrote. "But Shirreffs came close to scratching his superstar mare. 'I went into the racing office and spoke to [track CEO] Joe Harper and [racing secretary] Tom Robbins, and they told me that they knew how to fix it and that it wasn't a big deal, that they could add some water and it would be all right. That's exactly how it happened. The track was fine after the renovation break [at 7:30 a.m.].'"

So began what Harper would later declare "the best day Del Mar has ever had."

Zenyatta extended her career record to 18-0 with a neck victory over Rinterval, won with a typical hold-your-breath burst in the stretch to pass all five rivals. The Trakus report showed that taking the wide path, Zenyatta actually ran fifty-three more feet than the runner-up, roughly $6\frac{1}{2}$ lengths and a much better indicator than the victory margin of Zenyatta's stealth supremacy.

Zenyatta's final appearance on what had been placed on the promotional calendar as "Zenyatta Day" long before it was known whether she'd be there drew a crowd of 32,536—the largest turnout for a race card that wasn't Opening Day of the meeting or the Pacific Classic.

The crowd was laced heavily with folks wearing the pink and green colors of the Mosses' racing silks, sporting Zenyatta shirts and hats and carrying signs, homemade or mass-produced by industry affiliates, declaring interest and support (and dare we say love?) from everyday race followers, previously casual race followers and former non–race followers that possibly hadn't been seen since Secretariat.

This prompted Harper to say, "This is the best day Del Mar has ever had. And thanks to not just Zenyatta, but the style and eloquence of the people [Team Zenyatta] that you see in front of you. That makes it all a better story than just winning a race. Racing owes a great deal to these folks."

Team Zenyatta reiterated, reworked and reworded things it had said roughly seventeen times before and threw in a few moment-inspired possible originals.

"Certainly the best horse in the country ran at Del Mar today," Shirreffs said, laughing. "Would Joe [Harper] have anything less than the best horse in the country here?"

"This was Zenyatta," Smith said. "I wanted everyone to see her, and she showed up…She was Zenyatta. She's something to believe in…To me, I appreciate her more than my life itself."

Changes on the Surface

On January 31, 2007, Del Mar Thoroughbred Club president, CEO and general manager Joe Harper led a group of dignitaries onto the track to form a line in front of the winner's circle. They then began turning over shovels full of dirt to symbolize a major change—a conversion from the conventional dirt main track to the Polytrack synthetic surface, to be installed before the July start to the summer racing season.

Technically, the event was to comply with a California Horse Racing Board (CHRB) mandate that the state's major tracks convert to "a polymer synthetic type racing surface" by January 1, 2008. The CHRB had issued the mandate the previous May, coincidentally—or maybe not—only a few days after the widely viewed and ultimately fatal breakdown of Kentucky Derby winner Barbaro in the Preakness Stakes at Baltimore, which generated wide public outcry over track safety.

Del Mar had experienced a rash of breakdowns the previous summer that drew local media and public scrutiny proportionally equal to or greater than the national level in the aftermath of Barbaro, or, two years later, Eight Belles in the Kentucky Derby. Track officials had been researching newly emerging alternatives to dirt for years and were in the vanguard of a movement that got support from several horsemen's groups and provided the impetus for the CHRB involvement and its months of discussion, study and research before issuing the mandate.

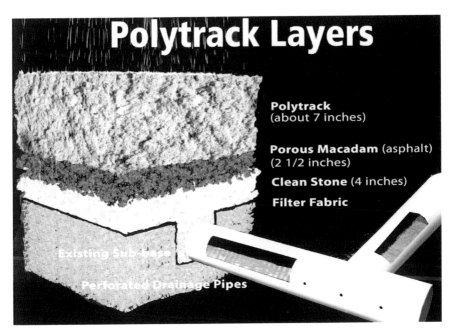

Polytrack Layers

Polytrack
(about 7 inches)

Porous Macadam (asphalt)
(2 1/2 inches)

Clean Stone (4 inches)

Filter Fabric

Existing Sub-base

Perforated Drainage Pipes

A diagram showing the composition of the engineered surface Polytrack, installed at the cost of $9 million before the 2007 meeting. *Courtesy DMTC.*

In truth, a surface change appeared inevitable at Del Mar long before it became an order.

Del Mar wasn't the first California track to install and conduct a meeting on an engineered surface. That distinction had gone to Hollywood Park, which had optioned for the Cushion Track brand for its fall meeting of 2006. Reviews from there were positive overall.

Polytrack was the brand chosen for Del Mar. DMTC officials had traveled to England, where it was developed for firsthand research, and consulted with counterparts at Turfway Park and Keeneland in Kentucky, Woodbine in Toronto and Arlington Park in Chicago, where it had already been installed. The all-weather aspects of Polytrack were part of the selling point to the tracks in the Northeast and Midwest, but not so much at Del Mar, where an "off" track happens about as often as the return of Halley's comet.

The ingredients of a Polytrack surface are basically the same as other brands: silica sand, recycled rubber, fibers and wax. The difference is in the specific elements and the mix. At a cost of $9 million, the new main track was put down—seven inches of Polytrack atop two and a half inches of porous macadam atop four inches of stone and gravel, with a layer of filter cloth between everything above and the existing sub-base.

Days before the opening of the 2007 meeting, DMTC executive vice-president Craig Fravel was asked about the genesis of the dirt-to-synthetic move. He said:

> *I think you can reasonably conclude that every racetrack manager starts thinking about changing racing surfaces the day they start managing the racetrack. It's the one thing where you constantly get complaints and up until recent years we never had an answer to them. We tried to give people the best and fairest racetrack we could, but one year it was good and the next year it wasn't.*

Polytrack made its debut on July 18, 2007, in the second race of an Opening Day card that drew an on-track crowd of 42,842, the second-largest turnout in track history behind only the 44,181 for the 1996 Pacific Classic.

Special Smoke, a gray three-year-old filly trained by Thomas R. Bell II and ridden by Jon Court, won the first race on the stuff, covering six furlongs in 1:13.95. Race-winning times were two or three seconds slower on average than they had been previous years on dirt, but on Opening Day, optimism reigned.

"I love it," Harper said. "I don't think, to the average fan, that time means anything. I don't think speed is always good for a horse."

"I like it [the surface] very much," said trainer Kathy Walsh. "I think we should give it a chance. You get full fields, close finishes and days like this, and the people are going to love it."

The honeymoon lasted all of twelve days.

In the stable area near the backstretch racing office on the morning of July 30, there was a chance meeting involving Harper, major owner Ahmed Zayat and Bob Baffert, who trained for Zayat.

The main track had produced a perfect safety record for the first two weeks of the meeting. But some concerns had been expressed over how a surface that was firm and fine for training in the cool morning hours was turning soft and strength-sapping under the warm California sun for afternoon racing. The effect was particularly evident on horses whose strongest attributes were speed or brilliance. Typically, Baffert had a bunch of those types, around twenty-five of them owned by Zayat.

Zayat's purpose was to inquire if something could and should be fine-tuned to address those issues.

"I think the bottom line was that he wanted to hear from me that we would change the racetrack," Harper said. "My response was that we won't

mess with it until the meet is over. We're certainly not, at this stage, going to go in and do stuff the inventor [Martin Collins] doesn't want us to do…We can't do anything to compromise the safety of the horses."

Harper's use of profanity when pressed for more consideration on the subject prompted Zayat to walk away, saying, "I've heard what I need to hear. I'm not staying here. Goodbye."

And within hours, Zayat, a Harvard-educated native of Egypt who made his fortune in the beverage industry in his home country, had made arrangements for two planes to whisk around two dozen of his horses to parts East.

"No one is against safety. You need a surface that is both safe and maintains the integrity of racing," Zayat said. "You can't take the speed out…Trainers are confused. Riders are confused. You have to have the honesty to work on the issues. I wanted to hear from the source [Harper] what they were going to do, and he totally snapped. I don't know him to be like that; he must be under a lot of pressure."

From that morning on, the surface at Del Mar was constantly a back burner and frequently a front burner item. Like other hot button issues in early twenty-first-century America—be it in politics, business or sport—

Hexadec protects the Polytrack surface during the weeks before and after a race meeting. *Courtesy DMTC.*

the synthetic track at Del Mar had a polarizing effect on insiders and outsiders alike.

Track management–compiled statistics of equine fatalities on the main track from 1997 to 2010 showed a significant decline in the four years following the 2007 installation of Polytrack, especially when compared to the four final years of the dirt surface.

Total main track fatalities from 2007 to 2010 averaged eight per season, with 3.75 per meeting in afternoon racing. The averages for the final four seasons on dirt, from 2003 to 2006 were 10 total and 8 during racing.

Skeptics and those of an anti-synthetic mindset questioned the validity and veracity of the numbers.

Praise or criticism from trainers depended on whom you were talking to and when.

Veterinarians at the stable-area equine hospital reported less activity and fewer procedures. Several trainers expressed concerns that the types of injuries synthetic tracks were tending to produce—especially in the hindquarters area—were as difficult for rehabilitation and recovery as the common ones they had been dealing with before the switch from dirt.

Track management commissioned studies and experiments on the surface between meetings and tweaked things year after year. The degree of success remained a matter of opinion.

Zayat's horses departed Del Mar in the summer of 2007. He stayed. And on the second anniversary of the spat, there were no hard feelings between Zayat and Harper.

"We kissed and made up, literally," Harper said. "Not on the lips, but on both cheeks."

Zayat expressed no regrets about what happened in 2007 and felt that subsequent events—track maintenance now routinely included watering and harrowing—provided vindication for the stance he took.

"It was never personalized to Joe," Zayat said. "It was just about the person who was in charge doing something, whoever that was…I love Del Mar. I love California. I love to be here."

In an interview on the eve of the 2009 Del Mar racing season, Richard Shapiro, chairman of the CHRB at the time of the mandate to synthetics but since retired, expressed some second thoughts.

"In 20-20 hindsight, I would not have pushed for a mandate," Shapiro said.

You ask me if I'm disappointed and, in a word, the answer is yes…They have lessened the fatalities but have not proven to be what we thought they

would. They require more maintenance and have not been as consistent as we anticipated. And while they have lowered fatalities, there are indications of problems with injuries that aren't fatal.

Clearly there's a divided constituency about them. I still believe they have promise and hope. To have done nothing and to have the [California] tracks continue to be harder and less safe would have been unconscionable…

If most of the industry wants to go back to dirt, they should go back to dirt. But I think that racetrack surfaces have become somewhat of a scapegoat for the problems of horse racing.

Racetrack surfaces are not the sole cause of breakdowns. There are many other factors including medications and breeding practices.

Shapiro said he would favor a lifting of the moratorium and return to dirt if that was the prevailing feeling in the industry.

Late in the summer of 2010, Frank Stronach, owner of Santa Anita, called a special meeting of horsemen at Del Mar to announce that the Pro-Ride surface at the Arcadia track would be taken up and there would be a return to dirt for the start of the winter/spring meeting in December. The announcement was greeted by cheers.

"We wish them well," said Craig Fravel, whose title now was Del Mar president and general manager. "We'll see if they come up with some kind of magic dirt. But we're happy with the stuff we have."

THE DARK SIDE

The high spirits and enthusiasm attendant to the start of any Del Mar meeting were sobered and stultified when six horses died in the first six racing days of the 1998 season. The dark reality of the sport—of which the typically casual, racing-unsophisticated patrons of a destination location track were likely only marginally aware previously—was brought into full harsh focus by the repetitive incidents and intense media scrutiny. Public outcry, led by animal protection organizations, inevitably followed.

There were page one pictures and stories in the newspaper—not page one in the sports section but page one of the whole paper. TV reporters doing on-the-spot reports and anchors back at the station offered stern opinion pieces. There was a plea to the racing board that the meeting be

shut down and placard-carrying, anti-racing pickets just outside the stable gate on the corner of Jimmy Durante Boulevard and Via de la Valle, the main thoroughfares leading to the track.

Everyone wanted to know why it was happening. Few seemed inclined to accept the standard racing answer that breakdowns were "part of the game," the inevitable but relatively rare consequence of thousand-pound animals traveling at speeds of thirty to forty miles an hour and making contact with the ground on legs with key bones no larger than the ones in a human wrist.

Among possible contributing factors suggested were: differences in the feel and composition of the tracks at Hollywood Park, where most horses had trained and raced for the prior three months, and Del Mar; underground inconsistencies due to Del Mar's unique proximity to the ocean and an extra strong effect of tides on the water table; and medication policies that might contribute to the masking of existing or preexisting physical problems with horses.

A subsequent California Horse Racing Board investigation found "no common denominator" in the deaths and placed no blame on the track. But the effect of the start of the 1998 season on the track's image and on track officials who had taken the heat, especially Harper, would not fade away.

An element of anxiety had infiltrated and taken up permanent residence at what was previously considered a close-to-idyllic atmosphere and close-to-paradise place.

A $500,000 project to renovate the dirt racing surface, in which the entire track was dug up to a depth of fifteen inches and layered with new materials, was completed during the course of the first five months of 1999.

There were still breakdowns and cries for action in the years that followed, but nothing like 1998—until 2006, that is. It was, especially at the start, a nightmare revisited.

The Opening Day crowd of 42,005 was the second largest in track history and nearly 10,000 more than the major-league Padres drew for an afternoon game twenty miles away at downtown PETCO Park. In the second division of the traditional Opening Day Oceanside Stakes, a one-mile race for three-year-olds on the turf course, a colt named Blazing Sunset suffered fractured sesamoid bones and was euthanized. Amidst everything else on the day, it was a note, not a headline.

The second day, there were four breakdowns in the first five races, one of which would prove fatal. On Friday, three days into the meeting, Harper and Fravel met with a dozen representatives of trainers and owners. There was another fatality on that late afternoon's program.

Once again, insiders and outsiders weighed in with theories and opinions regarding reasons for the disturbing developments. Once again, track officials urged trainers, owners, jockeys and veterinarians to err on the side of caution and scratch rather than run horses with which they had even minor concerns.

"I'd rather scratch ten good horses than have one marginal one that shouldn't go, go to the post," Harper said.

But the total mounted to seven fatalities in the first seven racing days. And July 27, 2006, was a flashback to 1998. The *San Diego Union-Tribune* had a page one picture, from the previous day's races, of a doomed horse named Esroh being led into the equine ambulance and an investigative piece accompanied by statistical charts regarding fatalities from races at the major Southern California tracks over the past five years, provided by the California Horse Racing Board.

The charts indicated that on average Del Mar, albeit with a seven-week season that was shorter than that of either Hollywood Park or Santa Anita, had a safety record that was on par—not significantly better or worse—with the Los Angeles tracks over the same period.

In the category of "Deaths per 1,000 starts," Del Mar recorded the top two of the fifteen listed, with 1.3 per 1,000 in both 2001 and 2002. The national average was 1.5. But the charts also showed that the numbers were on the rise in Southern California and highlighted the need, being expressed by various industry groups, for something to be done.

On the morning of the last day of the meeting, there were two fatal breakdowns during workouts, the seventh and eighth of the season, to go with ten horses that were euthanized from injuries incurred in afternoon races. "It detracted from the meeting greatly," Fravel said. "We all feel terrible when things like that happen. It is an element of the sport that historically keeps us from attracting and keeping new fans."

Fravel, who had spearheaded the effort to convert to a synthetic surface which would come to fruition the following year, had no expectations of it being a panacea for the problem. "But I believe it is a step in the right direction," Fravel said. "If it's a 50 percent drop [in injuries] or whatever, that will be meaningful. I do think that day in and day out the consistency of the surface will make a huge difference. If we can focus our attention on the racetrack surface and get that as good as we can, then we can start on other aspects of the problem.

THE MAGICAL MEETING OF 2003

It was supposed to be the "Summer of Seabiscuit." It turned out to be the "Summer of Julie Krone."

Seabiscuit, an eventual Academy Award–nominated film about the great horse whose exploits included a victory over Ligaroti in a 1938 match race at Del Mar that put the track on the national map, opened in theaters two days after the July 23 start of the 2003 meeting. It would top the $100 million mark in box office business before the meeting ended on September 10 and would be the impetus for a variety of promotions in the interim.

Amidst the flashing back and nods to nostalgia, however, came a racing force to be reckoned with, new to Del Mar, that hit the beachside track like a marine company off an amphibian in a training exercise at nearby Camp Pendleton. Krone, all four-foot-ten, 105 pounds of her, would have a giant impact in what would prove to be her only season at the place closest to the Carlsbad residence she had taken up three years earlier.

A hint of things to come came on Krone's Del Mar debut, an Opening Day that drew a crowd of 40,682. Krone was not long recovered from a literally backbreaking spill at Santa Anita four and a half months earlier, the third serious injury of her career. In her sixth ride of the day, on the eve of her fortieth birthday, Krone guided Devious Boy to a half-length victory in the Oceanside Stakes. Krone acknowledged the cheers and then turned them to laughter by jumping on the shoulders of massive professional wrestler Goldberg—in the winner's circle to present the trophy—and delivering a few playful rabbit punches.

It was a spontaneous thing, not scripted or suggested by track officials, something few besides Krone would have had the personality, spontaneity and creativity to pull off so delightfully. So Julie Krone. So Del Mar.

"This was really special for me," Krone said. "When pulling up afterward I started to tear up. There have only been a few times in racing where I've done that, but today was one of them. I have been injured and I have had to work so hard to come back. And it is so gratifying to have this happen and have it happen here at Del Mar. Today is a special day, and it feels so good to be back."

Krone led the rider standings through the first two weeks, winning four races on the final day of the second week to secure a one-win edge over Patrick Valenzuela. She lived up to her vow to "stay pesky on PVal" through the course of the meeting, taking it down to the final day before Valenzuela eventually prevailed by a 52-49-win margin. And there were wins of quality among the quantity of Krone victories.

The Oceanside triumph made Krone, the only female rider in thoroughbred racing's Hall of Fame, the first of her sex to notch a stakes victory at Del Mar. She would add eight more during the meeting, including the three events—the Pacific Classic, Del Mar Debutante and Del Mar Futurity—the track honors by having the winning owners' silks painted onto jockey statues in the paddock. The Pacific Classic was the first and most astounding of the three, not because of the outcome, but for the way it marked the intersection of the "Summer of Seabiscuit" and the "Summer of Julie Krone."

Candy Ride, a four-year-old colt discovered by Hall of Fame trainer Ron McAnally in Argentina, purchased for $900,000 and imported to the United States for San Diego owners Sid and Jenny Craig, came into the track's signature $1 million race undefeated and with a certain aura of mystery. His career began at bush tracks in out-of-the-way places in his native South America, where record keeping was not a priority.

"We don't know how many times he raced; they weren't recorded," Sid Craig said. "Somebody probably knows. But we don't know them."

Two victories at Hollywood Park, the last in the American Handicap on July 4, set Candy Ride up for seven weeks of training before the Classic, a race that Sid Craig had been obsessed about winning for over a decade. Hall of Fame jockey Gary Stevens, who could be seen playing George Woolf to Tobey Maguire's Red Pollard on the silver screen in *Seabiscuit*, was the rider for Candy Ride. Then, eight days before the Pacific Classic, Stevens suffered a collapsed lung and fractured vertebrae in his back in an accident at Arlington Park in Chicago when his mount, Storming Home, bolted in the final strides of the Arlington Million. Krone was chosen over Valenzuela and Mike Smith to replace Stevens. She rode the colt through one workout three days before the race, where Candy Ride would wind up with only three rivals, the most formidable being Medaglia d'Oro with riding legend Jerry Bailey.

It was almost spooky how life imitated art imitating life in a Pacific Classic for the ages. Elements of *Seabiscuit* mixed with real-life counterparts that, given only a dash of imagination, created an arc from the 1930s to 2003.

Candy Ride won by three and a quarter lengths over Medaglia d'Oro in a track record 1:59.11 for one and a quarter miles—or three-quarters of a length less than the margin by which Seabiscuit defeated War Admiral in the match race at Pimlico, also in track record time, at a 110-yard shorter distance. With two other horses entered, the Pacific Classic wasn't a match race. It just worked out that way.

Medaglia d'Oro and Candy Ride, the three-to-five favorite and two-to-one second choice in the betting, separated themselves from the other two the first time past the grandstand, maintained their advantage down the backstretch and then drew off by themselves with three-eighths of a mile to go. They were eyeball to eyeball for a few strides before Candy Ride drew off to record a sixth (officially, anyway) straight victory and hand Medaglia d'Oro, the number two ranked handicap division horse in the country, his first loss in four 2003 starts.

"When Candy Ride came to me and then went by, I just called out to Julie: 'Go get 'em, girl.'" Bailey said. "They were the best. My horse ran a good race, but we got beat."

It was the biggest victory ever for a female rider west of the Mississippi, giving Krone a bookend for the biggest win east of the Big Muddy, that coming on Colonial Affair in the 1993 Belmont Stakes. "Amazing, unbelievable," Krone said. "You just can't measure something like this. There is not a way to put a scale on it. It is the sweetest. I feel like I can fly."

Krone had met with Stevens a day before the race in a scene similar to one in *Seabiscuit* where an injured Pollard (Maguire) provides insight regarding the big horse to Woolf (Stevens).

"We had a Gary Stevens–Tobey Maguire moment," said Stevens, who greeted Krone in the winner's circle with his left arm in a sling.

> *Julie had seen some quotes about the horse, and she had rode* [sic] *him in a workout, so she had it figured. But she wanted a meeting. You react in races like this, but any little bit of information you can get to react to is a bonus.*
>
> *I just wanted her to know that you could run this horse to San Francisco and back. She breezed him the other day and she felt the power. But she needed to know how fit he was. The main thing I told her was if Bailey tries to sneak away at the half, just attack. It's like a match race when you're seeing how good your competition is. Take the battle to them. And the race was over at the three-eighth pole. She rode him to a "T."*

"Gary had me so excited after the meeting that I felt I'd already won the race," Krone said. "Going into the turn, I was reciting everything that Gary had told me and it went just like he said."

Six days after the Pacific Classic, Krone added the second jewel of the summer triple aboard Halfbridled in the Debutante, a five-length romp. It proved a portent of things to come two months later, when Halfbridled's two-and-a-half-length victory under Krone in the Breeders' Cup Juvenile Fillies made Krone the first female jockey to win a Breeders' Cup race.

Ten days after the Debutante, on the closing day of the meeting, Krone completed the triple, guiding Siphonizer to victory in the Del Mar Futurity. In his annual season-ending analysis, Harper called it "the best meeting ever," based on pure business numbers—and some mostly Krone-provided aesthetics.

"She was sensational," Harper said. "I don't think she just attracted more female fans here. I think she attracted more fans in general. They say she's the best female rider; she's one of the best riders period. To see her ride is a real treat. Her competitiveness, her skill and her everyday attitude were a major plus for us."

"This is so special to finish up this way," Krone said. "It has been such a wonderful and successful summer for me, and to close it out with a win in [the Futurity] is just the best. Del Mar is really cool. It's like the *Casablanca* of racing."

Injuries in the coming months would lead to Krone's retirement. It would turn out to be her only summer at Del Mar. But she, and the track's fans, would always have 2003.

AZERI 1-2

Before Zenyatta, there was Azeri. A four-year-old filly in 2002, she put together an incredible string of wins in Grade I and Grade II events that culminated with a smashing Breeders' Cup Distaff victory at Arlington Park in Chicago and subsequently being voted Horse of the Year. She was only the third female in history accorded an honor that wouldn't go again to a filly or mare until Zenyatta in 2010.

Azeri was inducted into the thoroughbred racing Hall of Fame that August weekend in 2010, and if fellow Hall of Fame classmate Best Pal was the most deeply San Diego–connected male to achieve racing's highest honor, Azeri was his female counterpart. Azeri was trained by Laura de Seroux, a resident of Rancho Santa Fe, a posh community just east of and bordering Del Mar. The training was mainly done at the San Luis Rey Downs center in Bonsall, twenty miles north of Del Mar and hard by the Brookside West farm, with its mile training track and stables, that was a West Coast headquarters for the worldwide racing enterprise of aerospace magnate Allen Paulson. Azeri was the product of a mating of Paulson's stallion Jade Hunter and Zodiac Miss. Azeri was foaled in 1998, two years before Paulson's death.

"I'm benefitting from probably twenty years of Mr. Paulson's breeding program," de Seroux said in 2002, when Azeri and stablemate Astra, two years older, emerged as the top-ranked female runners on dirt and turf. Paulson very astutely started purchasing well-bred fillies in the early 1980s from the Northern Dancer and Seattle Slew lines, raced them for a few years, found out which ones were good producers of runners and got them to the right stallions.

"The breeding and selection process takes time—over a decade—but when it works, you wind up with horses like Azeri and Astra," de Seroux said.

Azeri was the star of the stable for the Allen E. Paulson Living Trust headed by Michael Paulson, the youngest of three sons. In the irons aboard Azeri for the first eighteen starts of her career, beginning in November 2001, was Mike Smith. Two years away from election to the Hall of Fame, Smith had recently moved to the West Coast hoping to hit the refresh button on a career that had lost much of its formerly strong momentum in New York.

"I would definitely say Azeri restarted my career," Smith said. "I had done really well early in my career in New York but got hurt a few times and was kind of in a holding pattern. Before I left New York, I had dinner with [trainer] Shug McGaughey and I remember as clear as if it was yesterday him saying, 'All you need is that one good horse and it's going to put you right back on top again.'"

"I was familiar with Mike's story, and sight unseen, I put him on Azeri for her first race," de Seroux recalled. "He'd never worked her, never seen her, because she trained at San Luis Rey, and no jockey agents came around there. He was an accomplished rider trying to become established in Southern California and I thought I would support him."

Azeri would race twice at Del Mar, in the 2002 and 2003 Clement L. Hirsch Handicaps. They would be the fourth and eleventh victories in a string of eleven straight Grade I or Grade II stakes victories from March 2002 to August 2003.

"Both Clement Hirsches were races [where] we were extremely confident," de Seroux said.

The first one there was an anecdotal moment, a scenario. Mark Hennig sent out a filly from the East Coast named Mystic Lady. And Mark was the trainer of Summer Colony, the only horse to beat Azeri to that point and one that she would meet again later in the Breeders' Cup. So I'm thinking that this is a trial to see if they can figure out how to beat Azeri.

Azeri broke on top as usual and was cruising on the lead. Then as they were just past the half-mile pole heading for the three-eighths pole, Gary

Stevens on Mystic Lady made this very premature move and came zooming up from the back of the pack. It was odd, because you don't see horses make that kind of move at that point in a race. They even got a head in front of Azeri for a few strides, but then Azeri showed that she wouldn't get discouraged being headed and just pulled away.

The margin was two lengths, the time 1:42.60 for one and one-sixteenth miles. "We have a superstar in the making that I think will be great for racing," Michael Paulson said.

The second Clement Hirsch came with Azeri, the reigning Horse of the Year, on a ten-race winning streak. It was contested on August 10, 2003, seven years to the day after Michael's father sent his superstar, Cigar, in search of a record-breaking seventeenth straight victory in the Pacific Classic at Del Mar and saw the streak ended by Dare and Go in one of the biggest upsets in racing history.

"Azeri is a star like Cigar was, and Cigar was definitely one of the highlights of my father's life," Michael said on the eve of the race. "I remember the whole period where Cigar was in his prime and running. My father just beamed every time he saw him. We feel he left us Azeri, and it's kind of like divine intervention that she could be so special. We feel like she was a parting gift from my father."

Azeri went wire to wire, winning by three and a quarter lengths in 1:42.12.

"She was so 'on' today," Smith said. "She was so calm and cool. I'm usually cool, but she was ten times cooler than I was today. She was just out there, looking around and in the gate the same way. Just please the crowd, man, and that's what she does time after time."

The date and the Cigar connection? Simple coincidence. "We weren't believing that there was any kind of jinx or anything; we weren't going to have any part of that," Michael Paulson said. "We knew we put the best horse in the race, and she proved it."

Bridging the Centuries

They made their Del Mar debuts in the 1980s or earlier and were still making major marks into the 2000s. Trainers Bob Baffert and Bobby Frankel and jockey Patrick Valenzuela were no strangers to controversy, and the nature of their personalities and the degree of their success invited racegoers to take a stand for or against them, or switch sides at any given moment. No matter where you stood, they sure made things interesting.

WHAT ABOUT BOB BAFFERT?

In the early 1990s, Baffert could often be found on racing days in the grandstand at Del Mar or wherever live racing was being conducted on the Southern California circuit, mesmerizing the media and potential ownership clients with his outgoing personality and gift of gab while billing himself as "the poor man's D. Wayne Lukas." By the late 1990s, Bob Baffert was doing things at Del Mar that no one thought any horse trainer other than Lukas, the king of the 1980s and early '90s, would ever do.

Lukas won or shared four Del Mar training titles from 1982 to 1990. Baffert won seven straight from 1997 to 2003. Lukas saddled twelve winners of the track's two-year-old championship races (nine Debutante, three Futurity) between 1978 and 1996. Baffert greeted fifteen back at the winner's circle

(six Debutante, nine Futurity) from 1995 to 2009, among them an incredible seven straight in the Futurity from 1996 to 2002.

The first of Baffert's bunch of Futurity winners, Silver Charm (1996), would go on eight months later to win the Kentucky Derby, becoming the third in history to complete the Futurity/Derby double, joining Tomy Lee (1958–59) and Gato del Sol (1981–82). Baffert was responsible for bringing to and racing at Del Mar some of the most highly decorated (before or after their local appearances) horses in recent track history, including the five that provided him with his nine Triple Crown series victories.

Silver Charm won the Kentucky Derby and Preakness before losing to Touch Gold in the 1997 Belmont Stakes. Real Quiet, who appeared at Del Mar in September 1997, making his sixth, and final, unsuccessful attempt for a maiden victory, would blossom the following spring to win the Kentucky Derby and Preakness before losing to Victory Gallop by a desperate nose in the Belmont Stakes.

Point Given made his first two career starts at Del Mar in the summer of 2000, breaking his maiden in the second, a seven-furlong sprint. Upset as the favorite in the Kentucky Derby, Point Given would take the Preakness, Belmont, Haskell and Travers Stakes from May through August 2001 and be voted Horse of the Year.

Baffert purchased War Emblem three weeks before the 2002 Kentucky Derby for the Thoroughbred Corp. of Saudi Arabian prince Ahmed bin Salman bin Abdulaziz, for whom he had trained Point Given. War Emblem won the Kentucky Derby in wire-to-wire fashion and the Preakness from never worse than second place. He stumbled badly at the start of the Belmont Stakes and became the third Baffert horse in six years to come up short in a Triple Crown bid. Just over six weeks later, Baffert was on the elevated viewing stand along the backstretch at Del Mar when his cellphone rang, and moments after answering, he took on the look of a man in shock. He had been informed that Prince Ahmed had died of a heart attack at age forty-three.

"I just can't imagine him not being around," Baffert said. "He was not only a client, he was like family. When you go through something like the Triple Crown, you get very close, and we did…For this to happen to a guy who had such a passion for horses, it just leaves an empty feeling."

Eleven days later, on August 3, 2002, Baffert married the former Jill Moss in a ceremony at the storied Hotel del Coronado on Coronado Island, across the bay from downtown San Diego. One day later, the couple was on their way to New Jersey, where Baffert saddled War Emblem to a runaway three-and-a-half-length victory in the Haskell Invitational. Three weeks later, War

Emblem made his Del Mar debut in the Pacific Classic, the first appearance by a Kentucky Derby winner in the year of a Run for the Roses triumph in the history of the track.

War Emblem reared in the gate and was backed out twice before the start of the race. The Derby winner was barely back in the stall and not settled when, much to the chagrin of Baffert and jockey Victor Espinoza, the latch was sprung. The colt, whose best races were run on the lead, saw the front only briefly, turning into the stretch, before being passed by eventual winner Came Home. War Emblem faded to sixth in the stretch.

"They didn't even give him a chance to start," Baffert said. "He lost the break and that was his only shot. The only job [starters] have to do is get them out of there right, and they missed it."

War Emblem would be Baffert's last Triple Crown race winner before Lookin At Lucky in the 2010 Preakness. Del Mar followers were fully aware of Lookin At Lucky. Baffert had saddled Lookin At Lucky for victories in the Best Pal Stakes and Futurity in 2009.

<p style="text-align:center">❖❖</p>

Del Mar was the place where, in 1987, thirty-four-year-old Bob Baffert, looking to transition from training quarter horses to the higher-stakes, higher-profile breed, claimed his first thoroughbred, the place that Baffert, in the days before his 2009 induction into racing's Hall of Fame, singled out, above the Los Angeles–area tracks Santa Anita and Hollywood Park, as the "launch pad" for his success. Mike Pegram, the longtime friend and ownership client who convinced Baffert to switch to thoroughbreds, remembered the day.

"The horse's name was Hidden Royalty, and the guy who was with Bob said his [Baffert's] hands were shaking so bad he could hardly fill out the claim card," Pegram said. Baffert remembered driving down that day from Los Alamitos, the quarter horse track in Orange County just south of Los Angeles, pressed for time, battling traffic and wondering if he had the proper license to claim the horse. It turned out that a quarter horse license worked for thoroughbreds as well, and Baffert, decked out in the white Stetson he habitually sported then, made the transaction.

"The horse dwelt in the gate and got beat a bunch," Baffert said. "Brian Mayberry was the trainer, and his brother told me later, Brian looked at

me as we walked away and said, 'Who's the dumb cowboy that claimed my horse?' That horse ran a few times but didn't work out. We lost him to a claim for $10,000, and we were so happy to get rid of him."

The first thoroughbred Baffert bought at public auction would be named Thirty Slews, for the $30,000 purchase price and Seattle Slew ancestry. Thirty Slews won the 1992 Bing Crosby Handicap at Del Mar, with Baffert—not possessing a box to view the proceedings—watching on a monitor in a room named for training legend Charlie Whittingham. Thirty Slews would win the Breeders' Cup Sprint later that fall, proving that the Arizona cowboy could do some high-level training. Thirty Slews' victory in the race named for the track founder "really got me going," Baffert said. "Ever since then, I just couldn't wait for Del Mar."

When it comes to the seven straight Futurities, and back-to-back ones with Midshipman in 2008 and Lookin at Lucky in 2009, Baffert cites no favorites. "They're all special, because if you win the Futurity, you know there's a glimmering chance you might have a Derby horse," Baffert said. "Some horses I've won it with, I knew they had distance limitations or something. Others, like Silver Charm, it's very exciting because you know you've got a [Derby] chance."

It has not been all roses for Baffert at Del Mar. The switch to Polytrack was a trial, and Baffert was caught in the middle between valued client Ahmed Zayat and track management when Zayat and Harper got into the 2007 argument that resulted in Zayat removing his horses and Baffert commuting between Del Mar and Saratoga for the later part of the summer.

Two moments of satisfaction for Baffert amidst the artificial surface antipathy came in the 2009 and 2010 Pacific Classics when Richard's Kid negotiated the Polytrack for back-to-back victories. They were the second and third Classic scores for Baffert, joining that of General Challenge in 1999.

Near the end of the 2010 meeting, there were rumblings that Baffert might opt for Saratoga in future summers, which would deprive Del Mar of its number one trainer for stakes victories (90 to Charlie Whittingham's 74) and number four for total wins (359 to leader Ron McAnally's 434).

Still, Del Mar is the place where Baffert's parents and sister are longtime residents and where he has purchased a secondary home. It's where Pegram has a home on a hillside behind the backstretch with a view of the track. It's the place of which Baffert and Pegram have said, "You get a big smile on your face when you come here and a big frown when you have to leave."

Bobby Frankel, from Claimers to Classics

Robert "Bobby" Frankel was a love/hate relationship waiting to happen for anybody who had to deal with him.

You had to love Frankel for how smart and charming he could be, especially when his mood was right and the subject was thoroughbred racing, which he knew from every possible angle. You had to love him for his strong opinions, expressed without sugarcoating or fear of how they would be taken by anyone.

And as strong as the word might be, you could come to hate how, when his mood was wrong, he could be intimidating and dismissive and go into attack mode on any and every little thing. He was a guy who would spend hours with a rookie turf writer in 1985, schooling him on the daily backstretch rituals, the game as it is played at its highest levels and providing the Frankel take on the way racing was perceived and covered by the media; a guy who would go off on the same writer a year later when he had the audacity to write that runner-up Zoffany was making inroads on Al Mamoon in the stretch of the Eddie Read Handicap.

"Were you watching the race?" Frankel asked. "[Al Mamoon] wasn't getting caught, and he wouldn't have if they'd gone around again."

Before his death in late 2009 at age sixty-eight from cancer, Frankel had raced horses for thirty-seven seasons at Del Mar starting in 1972. He ranked fourth on the track's all-time list for training victories (349) and stakes victories (70). He won meet training titles five times, in 1973 and then from 1975 to 1978. He won the Pacific Classic six times with Missionary Ridge (1992), Bertrando (1993), Tinners Way (1994–95) and Skimming (2000–01). Bob Baffert and Richard Mandella are second with three Classic wins each. Frankel also saddled the winner in the meeting's most important grass race, the Eddie Read Handicap, seven times, the winners being No Turning (1977), Wickerr (1981–82), Al Mamoon (1986), Saratoga Passage (1989), Marquetry (1992) and Expelled (1997).

Frankel left memories all over the place.

"He was an interesting guy and a helluva trainer," track CEO Joe Harper said.

> *You could sense* [from the start] *that here was a guy who was different, that was bringing something new to the table. Of course, he had that New Yorker's edge to him, which I found actually was kind of fun. He was a critic and the years that he trained here, when you saw him coming you knew he had something to tell you that you were doing wrong. I never minded that*

either. You always knew where you stood with Bobby and I appreciated that about him. We would have some pretty good arguments over a wide variety of things, but I always respected him, and hopefully he felt the same way.

In the summer of 1985, Harper and Frankel, who was the head of the trainers' organization, faced a crisis. The Immigration and Naturalization Service had, almost annually, conducted raids on the Del Mar backstretch, usually early in the meeting, and hauled off undocumented workers to be taken across the nearby border to Tijuana, Mexico. Critics said it was mostly for the publicity. Supporters called it simply enforcing the laws of the land. When rumblings came of possible action in the summer of 1985, Harper and Frankel were the leaders on the spot.

"We had a potential disaster brewing, but Bobby took the position, almost militantly, that there was no way the government was going to interfere with the business going on at the track," Harper said. "But it was pretty obvious to me that they were going to take a very big interest and do something about it unless we could negotiate some kind of middle ground." A meeting was arranged at the INS headquarters in San Ysidro, California, the border crossing point.

"Bobby walked in," Harper recalled,

said "Hey, there's no way you're going to mess around with my horses at my racetrack," and walked out. That set the tone, and two days later there was a raid with 150 border patrol agents coming through the gates. Bobby wasn't around. He had left with a horse for Arlington Park. He wasn't on my good list for a while after that.

Frankel had the last word, leading a horseman's protest of the raid that resulted in one day of racing being cancelled because of insufficient entries. "He saw things from a point of view of racing, trainers and his operation," Harper said, "and I don't know if there was a lot of negotiating with him, I certainly respected him for his passion for the game, and boy, you certainly had to respect him for his ability as a trainer."

Born in Brooklyn, New York, Frankel was bitten by the racing bug at a young age. His reaction was to sneak into Belmont Park or Aqueduct, start with the lowest-level jobs and learn the game from the foundation up. He moved to California and became the king of the claiming trainers in the 1970s, then gradually acquired more substantial owners and transitioned the stable to higher-quality horses in the 1980s. He was given the Eclipse Award as trainer of the year in 1993 and again from 2000 to 2003.

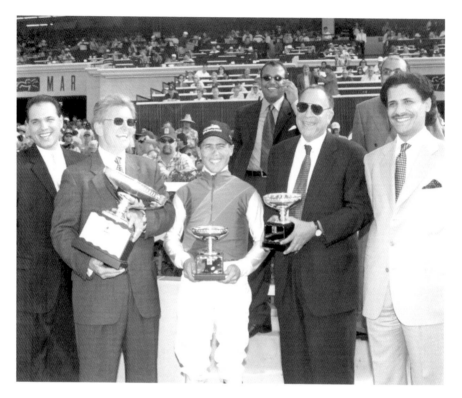

Trainer Bobby Frankel (second from right, dark glasses) won a record six Pacific Classics, the final two with Skimming, ridden by Garrett Gomez (center). DMTC president Joe Harper made the trophy presentation. *Courtesy DMTC.*

Frankel's Pacific Classic victories came in bunches and with horses whose running styles fit the scenario of how the races turned out that day. Missionary Ridge (1992) and Bertrando (1993) took their rivals wire to wire, while Tinners Way (1994–95) came from off the pace under the consummate come-from-behind rider Eddie Delahoussaye. Skimming (2000–01) wasn't supposed to be a mile-and-a-quarter horse but carried his speed for the distance in back-to-back, wire-to-wire wins under Garrett Gomez.

"Maybe it's the footing, maybe it's the salt air," Frankel hypothesized before the 2001 Classic of Skimming, which went undefeated in four starts at Del Mar. "He can get the mile and a quarter at Del Mar because he likes the track, so he can run a little farther. He runs the turns good, then when they turn for home, the wire is right in front of him."

After 2000, Frankel returned to his home state to oversee talented strings at Belmont Park or Saratoga and left assistant Humberto Ascanio in charge

of things at Del Mar. Skimming's 2001 Pacific Classic victory was one of seventeen stakes wins for the stable at Del Mar from 2001 to 2007.

Upon Frankel's death, the obituaries noted how Frankel won 3,654 races from 17,657 starters with purse earnings for his horses totaling $227,947,775 in a forty-seven-year career as a trainer. They noted how he had been inducted into racing's Hall of Fame in 1995, well before the real glory years of the early 2000s. They included quotes from horsemen who knew him well about what a giant he was in the profession and what a loss his passing was to the game. And the obits, most of them, included another not widely known fact in or out of horse racing: his daughter, Bethenny, was one of the stars of *The Real Housewives of New York City* and destined to later be the subject of her own reality TV show.

PVAL, MR. COMEBACK

The return to racing at Del Mar by Patrick Valenzuela on July 29, 2010, at age forty-seven, was his second major return to the track in eight years and ended a five-year absence. The gap in Del Mar meetings for his previous comeback extended from 1997 to 2002. All Valenzuela did for the 2002 comeback was win the meeting riding title that year, with 46 wins; he would do it again in 2003 with 52. All he did in 2010, jumping in a week into the meeting, was win 29 races—the over/under number in the press box had been 14—including four stakes, to set himself up as all-time number four at the track for victories, with 732, and number nine for stakes victories, with 63.

Suspensions resulting from drug abuse and personal problems cost Valenzuela an estimated seven years from a career begun in the late 1970s. During the 1990s, he was suspended by racing authorities eight times, and in 2000, another suspension kept him out of racing for twenty-two months. The California Horse Racing Board released a list of Valenzuela's infractions when it granted him a probationary license—heavily laden with both character and drug testing provisions— in July 2010 and rescinded a "permanent" revocation issued twenty-two months earlier. The "rap sheet" showed Valenzuela had twenty-eight fines or suspensions (excluding riding infractions and minor offenses) from January 1983 through September 2008.

The missing years, and the circumstances that caused them, may prove to prevent a rider possessed of great natural talent from induction into the Hall of Fame or consideration among the all-time best in the profession. But they didn't prevent the horsemen, horseplayers and general fans at Del Mar from warmly welcoming back the man commonly referred to as PVal on those occasions in 2002 and 2010 and tolerating both the bizarre and beautiful things that happened there in between.

The welcoming shouts from the crowd before the first race on July 28, 2010, were mostly one word: "Patrick." Returned from two years of banishment from California to Louisiana, Valenzuela finished second aboard Alaska Miss in the first race and third on his only other mount of the day in the sixth. "I feel really, really good to be back home," Valenzuela said. "I've had a lot of success in my career here, and I'm thankful to the California Horse Racing Board for showing me leniency. I always thought it would happen, I just didn't know when. I never stopped trying to get back here."

Trainer Peter Miller had to replace injured Tyler Baze on Alaska Miss and hastened to be the first to give Valenzuela a leg up in his comeback. "Patrick and I go back to when I was about ten years old and he was about seventeen, and he was our family's favorite," Miller said. "The biggest purse I ever won was the [$500,000] Nearctic at Woodbine [in 2006] with Fast Parade, and Patrick rode him."

Valenzuela's agent Tom Knust was pleased, but not surprised, with the support from horsemen for the return. "A lot of trainers and owners grew up with Patrick, and they realize, as do a lot of fans, that Patrick wants to win and he's going to compete every race. And he's upbeat all the time. That's what people want."

"If I continue to take care of my life on a daily basis, I won't need another chance," Valenzuela said. "I may not be leading rider again, but I'm going to have fun and enjoy my life…I think I've got ten more years of riding, and I'm going to do my best to make those ten years the best I've ever had."

Valenzuela's return to Del Mar in 2002, ending a six-year absence, was seven months into a comeback begun with the opening of the Santa Anita meeting on December 26, 2001. Things that happened when not on horseback had made Valenzuela a flower shop worker or truck driver for much of the past four years, banned from going to tracks and doing what seemed his destiny from birth into a family of riders. His uncle, Ismael "Milo" Valenzuela, won the 1958 Kentucky Derby on Tim Tam and the 1968 Derby on Forward Pass via the disqualification of Dancer's Image. Patrick put the family name back on the Derby record aboard Sunday Silence in 1989.

Valenzuela had won the Del Mar riding title in 1986 at age twenty-three, competing against and besting a colony that included then or future Hall of Famers Laffit Pincay Jr., Chris McCarron, Eddie Delahoussaye and Gary Stevens. When Valenzuela secured Del Mar championships again in 1990 and '91, his was the only name other than the above-mentioned quartet on the riding titles list from 1979 onward.

As Valenzuela set out on the comeback to start the new millennium, trainer Mike Mitchell—one of Valenzuela's longest-term supporters, best friends and biggest fans—"wouldn't ride him" on any of his horses. "I can forgive anyone, that's the Christian thing to do," Mitchell said. "But Pat had let me, his family and people close to him down so many times. I wanted him to come to me and talk it out face to face, man to man, friend to friend so I could see where his heart really was this time."

Valenzuela approached Mitchell—one of many such overtures to repair burned bridges with Southern California horsemen—and talked things out. After a slow start, he had forty-two wins and a sixth-place finish in the rider standings, then won seventy-four and the riding championship at Hollywood Park, the two-and-a-half-month-long meeting that precedes Del Mar. "I feel elated, the whole year has just been getting better," Valenzuela said as the Del Mar meeting approached. "The horsemen seem to be putting me on better and better horses. Hard work, perseverance and putting the Lord first is the foundation for the whole situation."

He won a division of the Oceanside Stakes on Opening Day of the meeting, his first stakes at Del Mar since 1996, and would also score in the Harry F. Brubaker Handicap awhile later. Those were his only stakes victories of the meeting, but Valenzuela proved he was back as an everyday rider with forty-six victories, twelve more than Alex Solis, to claim the jockey title. He would make a successful title defense in 2003, his fifty-two wins topping Julie Krone by three to complete a sweep of the three major Southern California meetings—Santa Anita, Hollywood Park and Del

Mar—that year. Valenzuela won seven stakes races, one fewer than Krone, and also prevailed in the "Battle of the Sexes" match race against Krone, which, as racetrack promotions go, turned out to be far less hokey than it had potential to be.

❖❖

Originally, it was going to be Krone versus Gary Stevens. That was the matchup announced in early July for the "Battle of the Sexes" race on Sunday, September 7, something to entice on-track turnout for a traditionally slow post–Labor Day weekend and possibly attract a little attention from general sports fans away from the opening of the NFL season. They were two Hall of Fame riders, Stevens inducted in 1997 and Krone in 2000. Stevens was one of the stars in *Seabiscuit*, and Krone was about to embark on her Del Mar debut season. Then, on August 16, at Arlington Park in Chicago, Stevens suffered a collapsed lung and fractured vertebrae in his upper back when he was unseated near the finish line of the Arlington Million after his mount, Storming Home, suddenly bolted to the right at the finish line of the race.

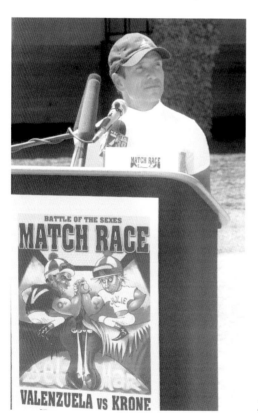

Substituting Valenzuela for Stevens was a natural. Valenzuela and Krone had been one and two in the rider standings and the focus of attention since the start of the meeting, much to the chagrin of others in the jockey colony. Following one race, in which Valenzuela on a front-running horse had been

Patrick Valenzuela meets the press at a podium adorned with the match race poster. *Courtesy DMTC.*

beaten by a Krone horse making an astounding late run, Valenzuela entered the jockeys' room receiving a heavier-than-usual ration of chiding for "getting beat by a girl." Valenzuela grabbed the microphone for the room's speaker system and said, in essence, "Yes, I just got beat by a girl. But in case you hadn't noticed, she's the only one in this room giving me any competition."

The race setup was as follows: a blind draw to determine mounts on two three-year-old colts, each with only one career victory, at one and one-sixteenth miles on the main track; a purse of $50,000; and win-only betting that would count in the rider standings. Krone got Woke Up Dreamin, trained by Bob Baffert, and Valenzuela drew Chester's Choice, trained by Summer Mayberry.

The buildup included none of the posturing or smack-talking common to similar made-for-promotional-purposes events in other sports. The quotes of both participants reflected respect between two professionals. Stevens, on the mend from his injuries, said that most young male riders coming up those days didn't have the "sixth sense" necessary to perform at the highest level that Krone had shown for years. "I'd no sooner want to hook up with her at the quarter pole than I would Laffit Pincay when he was on top of his game," Stevens said. "The second you let your guard down, she will nail

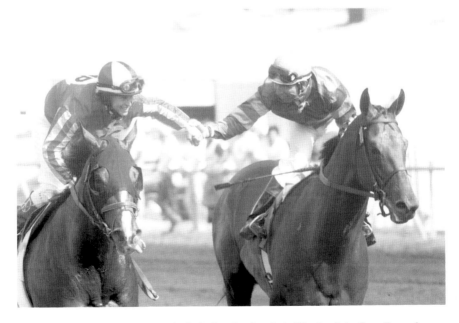

Julie Krone and Patrick Valenzuela shake hands after their "Battle of the Sexes" match race in 2003. *Courtesy DMTC.*

you. Julie Krone has paved the road for female jockeys. She has proved there is no sex barrier."

In the actual race, man, did Valenzuela cut it close. In the narrowest finish to a match race at Del Mar since Seabiscuit-Ligaroti in 1938, Valenzuela didn't spare any muscle or force as Chester's Choice made up two and a half lengths in the stretch to nose out Woke Up Dreamin at the wire. The fans in a crowd of 20,593 who had chosen "I Like Pat" buttons as a souvenir, went away only slightly more pleased than those who had opted for "I Like Julie."

Valenzuela pumped his arm and raised his whip immediately past the wire, knowing he had won. After the weigh-in, Krone kicked the ground in mock disgust and threw down her goggles to the delight of the crowd. "Bob Baffert said I could blame him if I lost," she said with a laugh. "So the last twenty yards, the training kicked in."

In the third race on the card the day after the match race, Valenzuela's mount, Grinding It Out, was disqualified from first to last place for cutting off Omar Barrio on Western Star. A subsequent scuffle between the two in the jockeys' room would result in $500 fines for both and a five-day suspension for the riding infraction for Valenzuela—nothing all that exceptional for racing or especially significant. But it proved to be an indicator of storm clouds building in the mostly sunny skies for Valenzuela the previous two years and set the stage for strange doings the following summer at Del Mar, when he should have been going for a third-straight riding title.

As the Del Mar 2004 season began, Valenzuela was in the sixth month of a wrangle with the California Horse Racing Board that had already cost him five months' riding time. He'd been suspended on January 23 for failing to show for a drug test, and the suspension had been upheld, and extended through the year, at a hearing on April 2. Two weeks later, CHRB chairman John Harris issued a stay of the suspension pending appeal, and Valenzuela resumed riding on April 25. On May 18, the board upheld the January 23 ruling but reduced the suspension to four months, less the three months already served, with provisions that Valenzuela could resume riding on July 1 at Hollywood Park. But he was ordered to perform one hundred hours in community service during the year and be subject to testing of hair follicles.

On July 2, Hollywood Park stewards issued another suspension, pending another hearing, after Valenzuela could not provide hair samples as required by the May order. When asked for a sample, Valenzuela reportedly remarked to CHRB investigators, "I can't give you what I don't have." And when the case carried over from the end of the Hollywood Park meeting to the start of Del Mar, it was up to the Del Mar stewards—Ingrid Fermin, George Slender and Tom Ward—to hold hearings and make a decision.

They did over three days in August in the stewards' room near the front-side racing office. The room, adequate for sessions to discuss previous days' infractions with riders or adjudicate stable-area problems, was overtaxed with the stewards, meeting recorder, legal representatives of the CHRB and Valenzuela and witnesses called to testify. Members of the press and other interested parties who didn't arrive early took seats or milled around just outside the door to listen to the proceedings.

In a two-hour session the first day, Valenzuela's attorney, Neil Papiano, asserted that since there had not been a specified hair length for a sample, Valenzuela had done no wrong in shaving his body hair. "How can you suspend him when nobody told him how long his hair should be," Papiano said. "You say you're going to suspend him but never tell him how long it has to be…You can't take a person's livelihood by surprise." California deputy attorney general James Ahern, representing the CHRB, contended that the relevant issue was whether Valenzuela's shaving his body hair was an attempt to conceal long-term use of "cocaine or methamphetamine," which only hair testing, not urine samples, would reveal. A forensic toxicologist testified that a sample of hairs one and a half inches long and about twenty milligrams in weight would be ideal to determine drug use over a period of three months.

The two-hour second-day session included the conclusion of the toxicologists' testimony followed by that of jockeys Danny Sorenson and Tyler Baze, Southern California racing circuit masseur David Stark and CHRB supervising investigator Michael Kilpack. Testimony focused on the extent and timing of the body-shaving habits of Valenzuela, who had kept his balding head close-shaven for quite some time. None of the witnesses could be date specific, however. Papiano introduced into evidence a photograph of Valenzuela's groin area—around a strategically placed hand—taken on July 7 and elicited the comment from Kilpack, "There's hair there," which Papiano contended was at a length greater than previous expert testimony indicated could be grown in a week's time.

The third and final session lasted two hours and forty-five minutes, much of which involved Valenzuela testifying in his own behalf when previous

indications had been that this would not be the case. Valenzuela said he shaved or trimmed his body hair "not on a regular basis but every once in a while." He said he was not aware of the hair-testing requirement condition of the May 18 ruling and didn't see the document until he was asked to provide a sample on July 2 in the stewards' office at Hollywood Park.

Five days later, the Del Mar stewards ruled that Valenzuela had been in violation of the terms of his conditional riding license and recommended that he remain suspended for the rest of the year and "not be considered for future licensing by the California Horse Racing Board in any capacity." One of Valenzuela's lawyers used the term "death penalty" in commenting on the severity of the decision—but of course it wasn't. In January 2005, an administrative law judge recommended that Valenzuela's appeal of the July and August decisions be granted, and the CHRB complied. Valenzuela resumed riding under terms of a new conditional license, which specified "maintaining hair on his head that is a minimum of 1½-inches in length."

He was back riding at Del Mar for a 2005 meeting that was, by his standards, mostly forgettable. He missed the 2006 and 2007 seasons due to injuries and personal problems and, in late 2007, ran afoul of the CHRB again, this time ultimately resulting in the September 2008 "permanent" suspension that was rescinded for the 2010 comeback at, where else, Del Mar.

The 1990s

Boom Times

In 1990, Del Mar retained its status, attained a year earlier, as the nation's leading track, with a daily average handle of $7,510,867. It would stay number one or number two, vying with Saratoga, for the rest of the decade as the daily average handle numbers rose to over $11 million and the average daily attendance (on and off track) stayed in the thirty thousand range.

It was a decade that saw the first 40,000-plus on-track day in history—44,181 for Pacific Classic Day in 1996 to see Cigar attempt to break Citation's mark of sixteen consecutive wins—and one that saw unprecedented success for the local Golden Eagle Farm and one of its color bearers, a native equine son of San Diego County.

NO CIGAR

"Never forget a day like that," Hall of Fame trainer Richard Mandella said on the tenth anniversary of arguably the biggest day in Del Mar history. That day was Saturday, August 10, 1996, when Mandella's Dare and Go, ridden by Alex Solis, passed Cigar in midstretch and went on to a three-and-a-half-length victory at odds of forty to one, turning the noise from the record crowd of 44,181 into stunned silence.

"That's one of the big days I've had and the joy of it was I wasn't sweating bullets," Mandella continued. "I knew my horses were going to run good, but I thought good meant second and third."

It was an incredible week in San Diego. Down Interstate 5 from Del Mar, the Republican National Convention had come to town, sending off its long-shot entries, Bob Dole and Jack Kemp, to run against incumbent president Bill Clinton and Vice President Al Gore. At the track, the Del Mar Thoroughbred Club prepared for racing's royalty by adding more security, but not enough to stop one creative fan from collecting an unusual souvenir. A woman snuck into the barn where Cigar was being kept, scooped up one of Cigar's "deposits" in a newspaper and strolled out with it, expressing the intention of having it bronzed.

Francisco Alvarado, the exercise rider for Dare and Go, told Solis that the horse was ready to go, and the inside information proved totally accurate. "One of the rare moments in my career when I won a race and people were booing me," Solis recalled. "It was incredible beating Cigar. You just don't get the chance to beat a horse like Cigar and end a streak [sixteen straight wins] like he had going."

Siphon, the stablemate of Dare and Go and a horse Mandella called a "streetfighter," set taxing fractions of 0:23, 0:45.80 and 1:09.20 for the first three quarters. Cigar chased Siphon in second, within a length or so all the way, and stuck a head in front in a mile covered in a scorching 1:33.60, two-fifths over the track record. And the toll of the pace, possibly misjudged by jockey Jerry Bailey, soon showed.

"I told everyone at the breakfast draw that I planned to take Dare and Go back because nobody should go with Siphon," Mandella recalled. "Bill Mott [Cigar's trainer] wasn't at the breakfast draw." As Dare and Go crossed the finish line, Mandella saw a woman breaking down and crying. Del Mar Thoroughbred Club president and CEO Joe Harper was struck by the silence of the crowd.

"It was the strangest finish of a race I've ever seen," Harper said. "Alex Solis said he could hear his horse's hooves as he crossed the finish line. There wasn't a sound. Governor Pete Wilson was going to present the trophy. He turned to me and said 'What do we do now?' I said 'Well, I think we still have a winner, Governor, but it's just not the one we thought we were going to give the trophy to.'"

Harper and Del Mar fans would be forever grateful to Cigar's owner, Allen Paulson. "Bringing a horse of Cigar's caliber to Del Mar for our biggest race added credibility to our race, to our facility," Harper said.

GLORY DAYS FOR THE HOME TEAM

John and Betty Mabee made their way through a thicket of handshakes and congratulatory pats descending the final flight of stairs at the front of the grandstand to the track level following the victory of their Best Pal in the inaugural running of the Pacific Classic in 1991. Then, upon reaching the winner's circle, they turned to face a standing ovation from much of the crowd of 28,134, the largest on-track number in the three years since the advent of intertrack wagering on the Southern California circuit.

"I'd never seen anything like that at a racetrack before, not for an owner," Best Pal's trainer, Gary Jones, would say years later.

The elation may have been partly fueled by the fact that Best Pal, a three-year-old going against older horses, hadn't been strongly supported by the professional handicappers and would pay $11.80 to those who backed the hometown horse. But maybe it was mainly for the Mabees, who were at the forefront in making San Diego County California's premier thoroughbred breeding area. And Best Pal's triumph in the Pacific Classic, heralded by his victory a year earlier in the Futurity, signaled the start of a decade of great racing success for John Mabee, who had already been the head of the Del

Del Mar Thoroughbred Club matriarch and patriarch Betty and John Mabee. *Courtesy DMTC.*

Mar Thoroughbred Club for twenty years at that point, and for his wife, Betty, a behind-the-scenes force in the family racing ventures and out-front face in their support of many local charities.

The Mabees, high school sweethearts in Iowa, came to San Diego in 1941 and established a mom-and-pop grocery in 1944 that grew to become the Big Bear chain of twenty-four stores. Ventures in real estate, banking and even a 20 percent ownership interest in the San Diego Chargers NFL team from 1963 to 1966 built wealth. The purchase of two thoroughbreds in 1957 sparked interest in racing and breeding. Later that year, they would purchase land near Ramona, in central San Diego County, and build it into Golden Eagle Farm, a 568-acre spread that was the top thoroughbred nursery in California. Upon John Mabee's death in 2002, Golden Eagle had about 400 horses, including 7 stallions, and the Mabees' band of broodmares was about 170 strong, spread between California and Kentucky.

The Mabees were the leading breeders in California ten times from 1990 to 2001 and won Eclipse Awards as the Outstanding Thoroughbred Breeder in North America in 1991, 1997 and 1998. At Del Mar, they topped the meeting ownership standings six times from 1990 to 1999 with their major stakes triumphs, including Futurity winners Best Pal (1990), River Special (1992), Winning Pact (1993), Souvenir Copy (1997) and Worldly Manner (1998); Debutante winner Excellent Meeting (1998); and Pacific Classic champions Best Pal and General Challenge (1999).

Best Pal's Pacific Classic triumph touched such a nerve with the Del Mar crowd because it was John Mabee, a founding member of the Del Mar Thoroughbred Club, who served as its president from 1978 to 1990 and chairman of the board from 1990 to 2001; the man who had been the driving force behind the establishment of the $1 million race that serves as the meeting's signature event. It was, unquestionably, Mabee's baby.

"I just didn't want to get disgraced, and he didn't disgrace us, did he?" John Mabee said afterward. "The horse was the choice of the public today. The handicappers did not pick him, but the public sent him off at nine to two."

"I know what it means to him to win this race, which is the culmination of a concept he has nurtured," said Joe Harper, proud to have presented the trophy to his mentor in track management. "John has always pushed us to take that big step into the big time. It's really something for us to finally be able to get this kind of race, and to have him win it is something else."

Betty Mabee, clutching the bouquet of roses, which contrasted nicely with her ivory suit, said it meant more to her than the American Beauties she didn't quite get the previous May when Best Pal finished second, beaten one

and three-quarters lengths by Strike the Gold in the Kentucky Derby. "I think emotionally this is greater," she said. "It's home ground, a special place for us. A Cal-bred. All of our friends are here to support us."

Sipping California champagne at a post-race toast, John Mabee looked to the Classic's future and said, "I don't want to be greedy and win it every year; some people might have some negative thoughts if we happened to win a few years in a row." Golden Eagle would have four representatives, Best Pal and Dramatic Gold twice each, in the next seven Classics without a victory. Then came a 1999 edition that overflowed with sentiment and provided a fitting end to the home team's decade.

Nine months earlier, Best Pal had died of a heart attack at Golden Eagle Farm in the course of his duties leading young horses to the training track. Five months earlier, a memorial ceremony and marker dedication had been held there. Then, in the ninth running of the Pacific Classic, John and Betty Mabee's new best pal became their new Best Pal.

General Challenge, a three-year-old gelding like Best Pal had been in 1991—and also like Best Pal, a Golden Eagle homebred—surged to the lead from the second spot out from the rail in a line of four horses nearing the second turn and went on to a three-length victory. "He went to the lead so easily, and the others weren't catching him," Betty Mabee said.

And then I began to realize as they turned for home—he's going to win this. Then, as he kept stretching out, I started to cry. So many parallels [to Best Pal], it was more than I could take. John cried a little there too at the last. I just couldn't believe we could do it twice. They're so different [General Challenge and Best Pal], you can't compare them individually. But who cares [about comparisons] if they win.

General Challenge had won the Santa Anita Derby in April and then finished eleventh after being bounced around roughly in the crowded first turn at the Kentucky Derby as part of the Mabees' favored entry, with the filly Excellent Meeting, which finished fourth in the Run for the Roses. A second-place finish in the Swaps Stakes in July at Hollywood Park didn't advance his Pacific Classic prospects, but the Del Mar crowd made him the second choice, at five to two, to six-to-five favorite Malek.

And for the Mabees, a Classic win was almost as sweet the second time around. "The original was something special," John said. "Maybe there is a little less joy here, but this is a special race for the Mabees. As I told Bob [trainer Bob Baffert], I'd rather win this race than the Kentucky Derby."

"He did say that," Baffert confirmed, "and I told him he was crazy."

John Mabee died in 2002, and Betty followed in February 2010. Six months later, Best Pal was inducted into the racing Hall of Fame.

EVERYBODY'S BEST PAL

A little perspective on the induction of Best Pal into Racing's Hall of Fame: it was entirely comparable to Ted Williams in baseball, Marcus Allen in football and Bill Walton in basketball, only this superior San Diego County–born athlete with a big heart and a strong will to win weighed around one thousand pounds, could run thirty to forty miles per hour and had four legs.

The brown son of Habitony out of the mare Ubetshedid was born on February 12, 1988, at John and Betty Mabee's Golden Eagle Farm near Ramona. He was raised, gelded and returned there for rest and recuperation periods during a six-year racing career starting in 1990. He died there, while performing the duty of leading young horses to the track for workouts, on November 24, 1998. He was buried there, and a memorial service in March 1999 attracted a throng of fans and followers.

"He was San Diego's horse; they loved him down here. He became San Diego's warrior," said jockey Patrick Valenzuela, aboard for Best Pal's first ten starts and ten others, including the emotion-stirring win in the inaugural Pacific Classic.

Gary Jones had become the trainer for Best Pal, replacing Ian Jory, two months before the Pacific Classic and was 1-0, with a victory in the Swaps Stakes at Hollywood Park, as Del Mar's first $1 million race neared. "Best Pal was a horse that made every trainer that touched him and every jockey that rode him look good," Jones said. "I know whenever he lost when I was training him, I'd go back to my charts and see what I'd done wrong. It had to be something I'd done, because the kind of horse he was, he wasn't supposed to get beat."

It's an axiom of the sport that "they all get beat." Best Pal did, twenty-nine times in forty-seven starts. But his eighteen wins included the Del Mar Futurity and Hollywood Futurity as a two-year-old; Swaps Stakes and Pacific Classic at three; Strub Stakes, Santa Anita Handicap and Oaklawn Handicap at four; Hollywood Gold Cup and California Cup Classic at five; Native Diver Handicap at six; and San Antonio Handicap at seven. He was

the California Horse of the Year from 1990 to 1992 and retired with Cal-bred record earnings at the time, $5,668,245.

Hall of Fame jockey Chris McCarron was aboard for thirteen starts and three stakes victories. "As a racehorse, he was all try," McCarron said. "I worried about him every time I had to ride against him, and I thought he gave me everything he had every time I rode him. He showed he was easy to ride because he had a lot of riders [seven]. He showed he was easy to train because he had a lot of trainers [Jory, Jones and Richard Mandella]. He was a hard horse to beat."

Valenzuela recalled riding a workout before Best Pal's first race, hopping off the modest-pedigree, physically unimposing Cal-bred and remarking to his agent, Bob Meldahl, "He might win for a $32,000 claimer." But Valenzuela was "blown away" by the unexpected speed and power Best Pal showed in his racing debut victory."

Best Pal was a runner but not a horse that enjoyed palling around with humans. "You know what I used to do if I didn't like somebody?" Jones asked.

> *I'd say go on in there to Best Pal's stall. They'd come out real quick. You didn't go in there unless you had a broomstick or a pitchfork in your hand. He'd hurt you. Oh yeah, he was very aggressive.*
>
> *You couldn't hit him—you'd come out second best for sure if you tried to do something like that—but even his favorite groom carried something into the stall until he had Best Pal's full respect. A lot of good horses are that way. They know what to do, and they just don't want to be messed with.*

Said Larry Mabee, John and Betty's son, "Dad got a lot of flack because he gelded the horse, but if he hadn't, you wouldn't have been able to handle him."

Pacific Classic week in 1991 got off to an ominous start in the Best Pal camp when a stirrup broke shortly after the start of the final workout for the race, compromising Valenzuela's control and resulting in a faster-than-desired time. "I looked at John and John looked at me and I said, 'There goes the Pacific Classic,'" Jones said.

Days later, the victory over standout older horses like Twilight Agenda, Festin, Farma Way, Itsallgreektome and 1990 Kentucky Derby winner Unbridled showed that Best Pal's best effort hadn't been wasted in a workout.

The story behind the horse's name was, it appears, purposely kept a mystery by the Mabees. When a writer asked whom the horse was named for after one of the big victories, John Mabee playfully replied, "You," and then followed up with, "Everybody's got a best pal."

Jones's theory was that Betty Mabee, who had the job of naming hundreds of Golden Eagle horses, chose it as a nod to her husband and the depth of their partnership. "That has been the assumption, but I can't shed any real light on the subject," Larry Mabee said. "It never came up in family conversations that I can remember."

Best Pal did not make *Bloodhorse* magazine's list of the top one hundred horses of the twentieth century, but it's doubtful that many who did had a better sendoff than the one Best Pal received in the headstone dedication and memorial ceremony in March 1999. An estimated three hundred people gathered around a huge oak tree near the farm offices. A podium and microphone had been set up, and those who wanted to stepped up and paid tribute, several while fighting back tears.

Joe Harper recalled, "He was an incredible horse, an inspiration for all of us in the business…As much as you can love a horse, we sure loved Best Pal."

John Mabee said, "Best Pal gave us a lot of joy and happiness in the years he raced. We were so proud of him so many times…He probably had more heart than ability, but you knew every time he went out to the track he would give all he had."

"I remember every second of every race he ever ran when I trained him," said Jones. "His four-year-old year, there was never a horse that was any better."

Jockey Corey Black, aboard for seven of Best Pal's races, added, "I'm not only a jockey but a huge horse racing fan, and I would have appreciated him even if I didn't get to ride him.

Gordon Personius, a resident of Union, Washington, who was visiting in the area and read a notice about the memorial in the newspaper, stepped up to read a poem he had written entitled "Epitaph for Best Pal":

> *Some have been named for heroes*
> *Or feats of great acclaim*
> *Some are called for yearnings*
> *Or for hopes of future fame*
> *Some may bear a family's tags*
> *Or perhaps an owner's aim*
> *But here forever lies a horse*
> *Who lived up to his name*

THE WALLS COME DOWN

The handwriting was literally on the wall as closing day of the 1991 meeting drew near. Right there on the ground floor, in the alcove where one waited for the rickety elevator for the ride to the long, narrow wooden press box on the roof, the word "stay" was scrawled on one wall and "remove" on another. It was a guide for demolition workers to follow regarding the grandstand, which hadn't been significantly changed since the track opened in 1937. And while Joe Harper and director of operations Harry "Bud" Brubaker would save the ceremonial first sledgehammer swings until a few days later, on September 11, soon after the stands had emptied following the last race, workers followed the instructions, and the walls on the western portion of the facility started to come down.

It was the beginning of an $80 million project, undertaken in two phases and completed in time for the opening of the 1993 season, that produced the present-day structure. The old grandstand was four stories high with an approximate seating capacity of fifteen thousand. On its footprint was

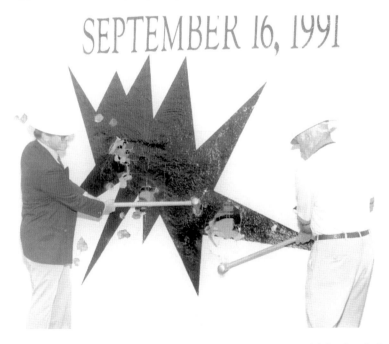

SEPTEMBER 16, 1991

Sledgehammers symbolically and literally tore at the old grandstand following the last race of the 1991 season. *Courtesy DMTC.*

built a six-story edifice with comparable seating capacity but undeniable superiority when it came to comfort, amenities and accessibility for patrons.

The original structure was partly financed by federal Works Progress Administration funds, as the state authorized Twenty-second District Agricultural Association to build a fairground on the present site to include a grandstand and one-mile racetrack. When those funds dwindled, Bing Crosby and a number of his Hollywood friends, who had formed the Del Mar Turf Club and signed a ten-year lease with the district to run the race meeting, borrowed money against their life insurance to finish the facilities.

Construction proceeded under the supervision of two architects from San Diego, Sam W. Hamill and Herbert Louis Jackson, who intended to evoke an era of Spanish Colonial grandeur. The basic structure was modeled on several of the old Spanish missions. "The theme was on a gay, happy note," Hamill recalled, "calculated to recreate the carefree days before taxes, freeways and tract houses. Our conception tried to recapture the spirit of the viceroys, the rancheros and the landowners and the gifted Franciscans."

The facility maintained its quaint feeling for more than fifty years, but time took its inevitable toll, and the project begun in 1991 had been in the works for years. The plan originally called only for "improvement and expansion," but it became clear that a new facility was the only answer. Engineers discovered that all the ground-floor studs had been eaten away, the wooden pilings had rotted and the main thing holding up the receiving barn—the stop for horses on their way to and from races—was the ivy growing on the walls. There were concerns about the structure meeting California's updated earthquake codes.

"The two main issues facing us," Harper said, "were how to pay for it and how to do it the right way. To have a design that would keep the feeling of the old one. Also, how to accomplish it all without losing a racing season."

Both issues were addressed in partnership with the staff in the offices of architects and general services of the State of California in the capital, Sacramento, and private enterprise. "We were kind of a darling of Sacramento," Harper said. "We had a history, and we were making money, so even the bureaucrats realized the importance of Del Mar." John Pushia, the state architect, was the key figure in choosing those who would design and build the structure. George Gomes, the chief of the Division of Fairs and Expositions, provided guidance on cutting through the red tape and getting things done.

Over about a three-year period before the start of actual construction, the financing fell into place. The Del Mar Thoroughbred Club put up about $30 million from its improvement fund and sold tax-exempt bonds at a low

interest rate until a total of about $90 million was raised to get the new grandstand and paddock area built. "We had already spent $15 million in the barn area to clean it up, built thirteen new barns, as well as living quarters for the backside help," Harper said.

Morio Kow, whose firm had designed Hollywood Park and redone Keeneland in Kentucky, was chosen as the architect for the project. Kow, who had never been to Del Mar before, was captivated on his first visit and immediately told Harper that keeping the mission-style feel was of utmost importance. One condition Harper insisted on was that the public be able to see the horses when they emerged from the receiving barn to head for the paddock, so Kow suggested a design that would face both front and back, an unprecedented approach in California. Kow consulted with horsemen about the size of the paddock, as well as the size and location of the jockeys' room. "I don't think we can build this in one year," Kow informed Harper. "We're going to need two to three years."

It was done in two. It meant the 1992 season would be staged with a half-completed facility and enduring complaints from those who saw the glass as half broken rather than half empty or half full.

Centrex Golden Construction Company did the brick, mortar and other work. The task was a huge one, complicated by the fact that the new grandstand needed to be supported by steel columns, for seismic reasons, and because of the spongy texture of the soil due to its proximity to the

Demolition of the old grandstand and construction of the new took place over a two-year period from 1991 to 1993. *Courtesy DMTC.*

ocean. Centrex Golden had already won a Build America award, however, and the project manager, Fred Hummel, had once been the state architect. He had built the Reagan Library, knew his way around the bureaucracy and had two loves—horses and flying. "Fred was tremendous," Harper said. The project was a year ahead of schedule and under budget.

On Opening Day of the 1992 season, fans were ushered into a half-completed facility, a new grandstand nestling alongside the old clubhouse and turf club. The new paddock was still unfinished, but Harper had arranged for a painting of it for people to see what it would look like. He immediately got some nasty letters from fans who thought the painting would be all they'd get. There were also many objections to the steel columns, which partly obstructed views from some seats. "Now I know what the call to the post means," one irritated horseplayer wrote.

The rest of the project was completed between the 1992 and '93 seasons. Governor Pete Wilson, a former mayor of San Diego, was on hand for the celebration on Opening Day 1993. A new era was begun in which longing for the past seems to have gradually given way to acceptance of the present. Access to views of the horses in the paddock from the rear of the structure, and the races themselves from the front, are far greater than pre-1993, as is access to food stands and betting windows on all but the most crowded of occasions, such as Opening Day and Pacific Classic Day. But those who remember the old days can be forgiven for an occasional twinge of nostalgia. Harper included.

On that final day of racing in 1991, he remembers going to the box seat area in the grandstand that was his mother's for many years to watch the last race. He was four or five years old when he first went there to sit in the old rattan chairs that had pinched his legs as he sat on them in shorts. "There were so many old memories that I almost cried," Harper recalled.

The 1980s

Along for the Great Riders—and Trainers

O n any given day, and sometimes in a given race, horseplayers at Del Mar in the 1980s might have the option of choosing among six current or future Hall of Fame riders upon which to put their money.

Bill Shoemaker (Hall of Fame class of 1958) was in his fifties but still booting home more than an occasional winner and recording 25 of his 94 career stakes victories at the track, which still ranks in the top five on the all-time list. Sandy Hawley (Hall of Fame class of 1992) recorded 11 of his 17 stakes victories at Del Mar from 1980 to 1985. Laffit Pincay Jr. (Hall of Fame class of '75) was in his thirties—very much in his prime. From 1980 to 1989, he notched 43 of his 95 stakes victories, tied for third overall through 2010, and counted meet riding titles in 1982 and '85 with 58 and 52 victories, respectively. Chris McCarron was building his resume for Hall of Fame induction in 1989 with Del Mar riding titles in 1980, '81, '83 and '84 and his reputation as a "money" rider with 57 of his track career-record 134 stakes victories in the ten-year span. Eddie Delahoussaye (Hall of Fame class of '93) recorded 40 of 94 Del Mar stakes victories in the 1980s and got fans there, as he did at every other track, accustomed to his signature come-from-behind victories, timed to get his horse in front as close to the wire as was humanly and equinely possible. He capped the decade with his only meet riding title, achieved with 44 victories in 1989. Gary Stevens (Hall of Fame class of '97) debuted at Del Mar in the mid-1980s, won riding titles in 1987 and '88 and was just warming up, recording 14 of his 79 stakes victories, from 1985 to 1989.

Horseplayers also had options of choosing among six current or future Hall of Fame trainers, three of whom would be the major forces of the decade in their profession at Del Mar. Charlie Whittingham (Hall of Fame class of 1974), a native San Diegan who was on hand when the track opened in 1937, saddled 34 stakes winners in the 1970s and added 26 more in the '80s toward his career total of 74 at the track, second overall through 2010. Ron McAnally (Hall of Fame class of '90) had bookend meet training titles in 1980 and '89, went to the winner's circle following stakes races fifteen times en route to his 73 career total and continued to build an overall win total that stood at a track high of 434 in fifty-one seasons through 2010. In between, D. Wayne Lukas was having the same major impact at Del Mar that he was having on the rest of the Southern California circuit and the nation. In the 1980s, Lukas won 32 stakes of his Del Mar total of 48 and evidenced the strength and depth of his "program" for two-year-olds by saddling seven Debutante and three Futurity winners during the decade with two of the Futurity triumphs coming by racing fillies Althea and Lost Kitty against males in 1983 and 1987.

CHRIS MCCARRON

In the last race of his career, Chris McCarron rode Came Home to a clear victory in the $100,000 Affirmed Handicap on June 23, 2002, at Hollywood Park. McCarron, then forty-seven, pulled the plug on a twenty-eight-year career that produced 7,141 wins, the sixth highest ever at that point, and included two victories each at the Kentucky Derby, Preakness and Belmont Stakes; 849 of the wins were recorded in twenty-four seasons at Del Mar, a track record 134 of them in stakes.

There was only an eight-day period between McCarron's announcement of his decision to retire and the last ride. Seven weeks earlier, the day after riding Came Home to a sixth-place finish in the Kentucky Derby, McCarron had cancelled plans to return to California and instead watched the race he was supposed to ride, the Inglewood Handicap at Hollywood Park, on television in a hotel room. "I'm ashamed to admit this, but I had no guilty feelings about not being there," McCarron said. "Something was wrong because I should have felt guilty. But there was no longer a big, bright flame burning. It was down to a little flicker. I could feel that big flame had been extinguished."

The Del Mar connection of the future to McCarron's retirement was Came Home. McCarron's last Derby mount and the last ride and victory of his career would, two months later, win the Pacific Classic under Mike Smith. The Del Mar connection on the day of McCarron's retirement was Gary Jones, who, though retired himself, represented the trainers' fraternity in post-race ceremonies.

"I asked several trainers for one word to describe Chris," Jones said. "I got 'phenomenal,' 'fantastic,' 'professional,' 'style' and 'class.' A lot of people don't realize, but Chris was that way when he got [to Southern California]. He was that way when he was nineteen years old."

Born in Massachusetts to a family with no racetrack background, McCarron followed his older brother, Gregg, into the jockey profession after a customer in the department store where Gregg was working suggested, mainly based on his diminutive size, that he might have a future at the racetrack. In 1974, Chris set a record with 546 wins and was presented the Eclipse Award as the Champion Apprentice Jockey; a few years later, he moved to California seeking the greater fame and fortune.

McCarron's first stakes victory at Del Mar came aboard Happy Holme in the 1978 Rancho Bernardo Handicap. It would be his only stakes score that year, but he would record multiple stakes triumphs every year for twenty-two of the next twenty-three seasons, the lone exception being a 1990 meeting missed due to injury. The highs were twelve stakes victories in 1995 and ten in 1988; the lows were two stakes wins each in 1985 and his final season in 2001. His Grade I victories at Del Mar came aboard the appropriately named filly Flawlessly in the Ramona Handicap three years in a row, from 1992 to 1994, and Free House, for the same owner/trainer connections as Came Home, in the 1998 Pacific Classic. He took the Eddie Read Handicap aboard Wickerr in 1981, seven years before the race would gain Grade I status, and had victories in the Bing Crosby Stakes (one), Chula Vista/Clement L. Hirsch (seven), Del Mar Oaks (four), Debutante (four) and Futurity (three) before those events were elevated to their present-day Grade I level.

LAFFIT PINCAY JR.

Fittingly, the capper to Laffit Pincay Jr.'s final milestone at Del Mar, his 1,000th career victory at the track, came aboard a horse named Chapeau (French for "hat"). It happened in the sixth race on August 19, 2002, after

being trained by Hall of Famer Ron McAnally for local resident owners Sid and Jenny Craig. "This feels so great," Pincay, then fifty-five years old, said. "Del Mar is a special place for me. It always has been."

Pincay made a special entrance, winning six races from eight mounts in his Del Mar debut on July 28, 1976, opening day of the meeting. It tied the record for wins in one day set by Bill Shoemaker twenty-two years earlier. Two years later, Pincay would go six for eight again. The mark stood until Victor Espinoza went seven for ten on September 4, 2006.

"Everyone had been telling me what a wonderful place it [Del Mar] was, and I really wanted to go," Pincay recalled. "I had six winners on the first day and I almost broke Shoe's record [ninety-four wins in 1954] for the season. If they hadn't given me the suspension, I think I would have broken it." Pincay had eighty-six wins in thirty-eight days, missing five days while suspended for a riding infraction.

Twenty-six more seasons at Del Mar would follow the memorable first one. The victory total, begun aboard a horse named Scumpa that opening day in 1976, would reach the one hundred mark in '77, two hundred in '79, three hundred in '80, four hundred in '82 and five hundred in '84. The pace would, understandably, slow down for the next five hundred as the six hundred mark was achieved in 1986, seven hundred in '89, eight hundred in '93 and nine hundred in 1999. Pincay would tack riding titles in 1977, '89, '82 and '85 behind the one in '76. But the competition got younger and tougher. And the "what have you done for me lately" nature of the business—no less evident at Del Mar than anywhere else—resulted in a drop in both the quantity and quality of mounts.

From highs of eleven stakes victories at Del Mar in 1976, nine in 1983 and eight in 1987, Pincay was down to single stakes wins in 1996, '97 and '99. Then, as he closed in on Bill Shoemaker's career-record 8,833 wins, it seemed like Pincay was rediscovered by the circuit's owners and trainers. He would record win number 8,834, overtaking Shoemaker, on December 10, 1999, at Hollywood Park, and the 9,000 mark as part of a five-win day at Santa Anita on October 29, 2000; he kept going strong through the 2001 and 2002 meetings at Del Mar.

In a column in the *San Diego Union-Tribune* shortly after Pincay's 1,000[th] Del Mar victory, Nick Canepa wrote:

> *He's at the old speed limit, 55, an age—given his wealth and good health— when he should be sitting on a veranda looking at the Mediterranean, not the horse's rear end in front of him…He has absolutely nothing more to prove…*

His place in jockey history isn't going to be moved…But he won't quit, because he doesn't want to…He's a race rider. The best there has ever been at it…

This, ladies and gentlemen, is an incredible human being. This is one of the greatest, most productive of all modern athletes. Many athletes continue past their prime, but there are times when I see Pincay, charging down the stretch on his noble steed, and wonder if he has even reached his prime. How fortunate are we to be able to watch the best, the Ruth of his game.

Pincay increased his Del Mar total to 1,011 wins as the 2002 season ended in early September. He was approaching the 9,500 mark for his overall career and expressed the intention of riding for years to come. Six months later, in a spill at Santa Anita, Pincay suffered a broken cervical-2 bone in his neck, one of the uppermost of seven vertebrae of the spine. The man who had come back from a dozen collarbone breaks, ten broken ribs, two spinal fractures and two punctured lungs made every effort to do so again, but on April 29, he announced his retirement upon the recommendation of physicians. His career ended with 9,530 wins.

On August 31, 2003, Del Mar dedicated a day in Pincay's honor. Proclamations declaring Laffit Pincay Jr. Day in Del Mar and San Diego were presented, and track president and general manager Joe Harper announced that a plaque of Pincay would be placed on the grounds alongside those honoring Bill Shoemaker and John Longden. Addressing the crowd, Pincay said, "I agree with Chris McCarron [retired in 2002] when he said you are the best fans in the country. I thank Del Mar for giving me the opportunity to say goodbye…I am proud of everything I have accomplished here."

Pincay's 1,011 wins top the track's career list. Shoemaker is next with 889, and McCarron is third at 849. Patrick Valenzuela, still active through the 2010 season, is next at 732.

EDDIE DELAHOUSSAYE

The jockeys' race in the 1989 Del Mar meeting was as tight as any could be. It came down to the final day, with Laffit Pincay Jr. and Eddie Delahoussaye tied with forty-two wins each and Gary Stevens with forty-one.

Halfway through the meeting, it appeared Pincay was on his way to a sixth meet riding title, but then an extended slump allowed others to get back into

contention. Delahoussaye topped the standings before an eventful Labor Day weekend in which he a) received notification of a five-day suspension he would serve during the final week of the meeting; b) made a trip to Chicago for a stakes assignment only to learn, upon arrival, that his mount had been scratched; c) narrowly missed getting back to Del Mar in time to pick up a stakes ride the same day; and d) had his stakes mount in the Labor Day feature scratched due to injury.

Stevens, seeking his third straight Del Mar title, saw his chances end with a broken wrist incurred in a spill four days before the end of the meeting.

Pincay and Delahoussaye had eight mounts each on the card. Delahoussaye broke the tie with a victory in the third race, a one-and-three-eighths-mile turf marathon, aboard favored Flippable for trainer Ron McAnally, a victory that would also clinch the training title for McAnally. Delahoussaye won again in the sixth race, one and one-sixteenth miles on the turf aboard Petrel's Flight for trainer David Hofmans. Pincay's best result was a runner-up finish, and Delahoussaye claimed his only riding title of a twenty-four-year Del Mar career which, with seven hundred overall victories and ninety-four stakes wins, tied for fifth with Bill Shoemaker on the track's list.

"I was doing all right, having a good year before Del Mar, and it just got better," Delahoussaye recalled before the start of the 1990 season. "When they're running good for you, you better enjoy it, because the business runs in cycles."

Delahoussaye produced a remarkably consistent stakes record in twenty-four seasons at Del Mar. He recorded four or more stakes victories in sixteen of them, with highs of eight in 1993 and six in 1980, '81 and '92. It was Delahoussaye who piloted Gato del Sol, a gray son of Cougar II, to victory in the 1981 Del Mar Futurity and, eight months later, a win in the Kentucky Derby, the first of back-to-back triumphs in the Run for the Roses for Delahoussaye. He took it again in '83 aboard Sunny's Halo.

Delahoussaye would do the back-to-back thing in Del Mar's signature race, the Pacific Classic, in 1994 and '95 aboard Tinners Way, providing trainer Bobby Frankel the final two of his four straight Classic wins. The story that came out of the 1994 race was that Delahoussaye chose Tinners Way over Best Pal, much to the surprise of Frankel. "I saw Eddie, and I said, 'Are you crazy?'" Frankel recalled.

Crazy like a fox, it turned out, when Delahoussaye drove Tinners Way between horses three paths out from the rail turning into the stretch and gamely held off Best Pal, which went five wide under McCarron and won

Above: Concerts with groups like Devo, Gnarls Barkley and Jack Johnson attract huge crowds to the infield stage. *Courtesy DMTC*.

Left: Zenyatta shares a laugh with groom Mario Espinoza before her third and final Clement L. Hirsch Stakes victory in August 2010. *Courtesy* San Diego Union-Tribune, *Earnie Grafton*.

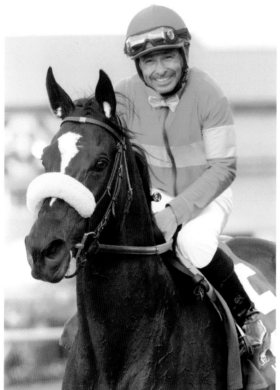

Above: Zenyatta narrowly defeats Anabaa's Creation in the 2009 Clement L. Hirsch Stakes. *Courtesy DMTC.*

Left: Mike Smith brings Zenyatta to the winner's circle after one of her three victories in the Clement L. Hirsch Stakes, 2008–10. *Courtesy DMTC.*

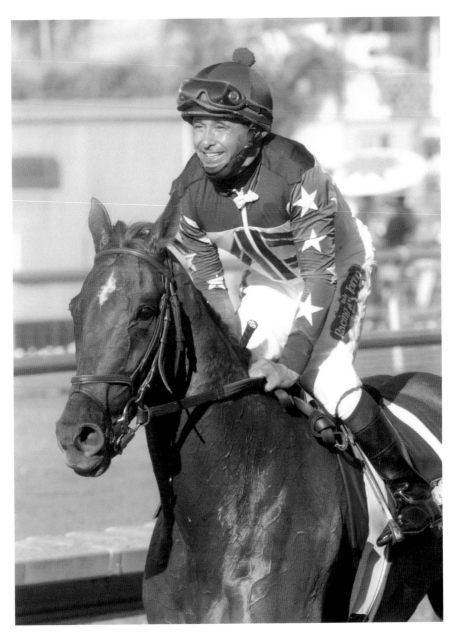

Mike Smith brings Azeri back to the winner's circle after one of her two victories in the Clement L. Hirsch Stakes in 2002 and 2003. *Courtesy DMTC.*

Above: Bob Baffert and son Bode have been frequent and photogenic visitors to the winner's circle. *Courtesy DMTC*.

Left: Bob Baffert dominated the trainer standings from 1997 to 2003 and became the track's all-time leader for stakes victories. *Courtesy DMTC*.

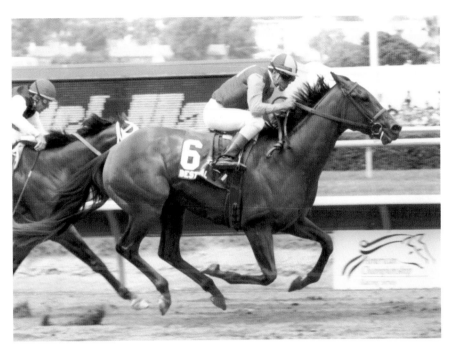

Above: Best Pal, owned by the Mabees and ridden by Patrick Valenzuela, wins the $1 million inaugural Pacific Classic in 1991. *Courtesy DMTC.*

Below: The paddock and grandstand on a typical Del Mar day. *Courtesy DMTC.*

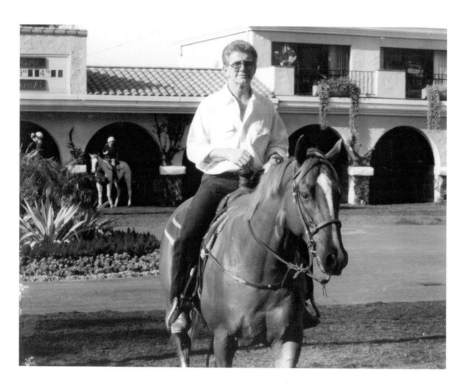

Above: DMTC CEO Joe Harper. *Courtesy DMTC.*

Below: Academy Award–winner Kevin Costner (right) is among the modern-day Hollywood stars who can sometimes be found at Del Mar. *Courtesy DMTC.*

The late television mogul Merv Griffin owned Stevie Wonderboy, winner of the 2005 Del Mar Futurity. *Courtesy DMTC.*

Modern-day Del Mar tradition includes patrons singing "Where the Turf Meets the Surf" between races. The tradition got off to a rough but entertaining start when NFL quarterback Drew Brees (left) and ESPN commentator Kenny Mayne butchered the inaugural rendition. *Courtesy DMTC.*

by a length. In 1995, Tinners Way was three wide most of the way while staying within a length and a half of pace-setter Slew of Damascus for the first three-quarters and then moved up to challenge when Soul of the Matter moved inside Slew of Damascus to take a half-length lead rounding the second turn. "I thought it was over. He gave me the thrill of victory for a short while," said Kent Desormeaux, who rode Soul of the Matter. "And then Eddie just ran away from me."

"When Kent got through, I still thought there was no sweat," Delahoussaye said. "When I asked my horse, he fired."

Delahoussaye was troubled by sinusitis through the 1994 and '95 seasons at Del Mar—he had only four victories from fifty-six mounts before the '95 Classic—but the Tinners Way triumphs were physically and mentally soothing. In both races, Frankel, who could be demanding at times, left the race strategy to Delahoussaye. "I told him, you ride him any way you want to ride him," Frankel said. Delahoussaye added, "If the rider knows the horse, you're better off leaving him alone. If he doesn't know the horse, that's a different story."

The Pacific Classics would be two of six Grade I wins at Del Mar for Delahoussaye. Prior to the Classics, he had won the Ramona Handicap aboard Short Sleeves in 1987 and the Eddie Read in 1988 and '89, the first with Deputy Governor and the next with Saratoga Passage. His last Grade I came aboard Affluent in the 2002 John C. Mabee/Ramona Handicap in what would prove to be his final Del Mar season.

His last victory at Del Mar came on August 25, 2002, aboard a filly named Real Paranoide. It was done in the signature fashion of the native of Iberia, Louisiana, coming from far off the pace with a late run timed for arrival on the lead just before the finish line. Five days later, a spill would result in a hairline fracture of the neck and concussion. The following January, on the advice of doctors, Delahoussaye, fifty-one, announced the end of a thirty-five-year riding career that produced 6,384 wins from 39,213 mounts.

Soon after announcing his retirement, Delahoussaye reflected on his days spent at Del Mar. He said he liked the family atmosphere and the way racetrackers would socialize and dial the competitive intensity down slightly for a little while. But being honest as he invariably was, he had to say the place was tough on him.

"I had some great years there, but since 1979, it seems like I got hurt about three out of every four years at Del Mar," he said. "I don't know why that is. In '82, I got kicked [waiting to mount up] in the saddling paddock. Four years ago, I broke my shoulder. I got a lot of injuries there. But I'll still look back at the good times a lot more than the bad."

Gary Stevens

Gary Stevens was the keynote speaker for the 2010 Hall of Fame induction ceremonies, where the trio of Del Mar standouts would be called to step forward and be honored. Appropriate, since Stevens had certainly left a major mark at Del Mar, among many other places, before and after his own induction into the Hall of Fame in 1997.

A native of Idaho, the son of a trainer, Stevens was working around the stables by age eight, and in 1979, at age sixteen, he notched his first thoroughbred victory in his first race, on a horse trained by his father, at Les Bois Park in Boise, Idaho. Stevens established credentials with riding titles in 1983 and '84 at Longacres, outside Seattle, that made him a hot prospect to succeed on the Southern California circuit, despite the established talent in the colony. And from 1986 to 1988, he proved himself by winning two riding titles at all three of the major meetings: Santa Anita, Hollywood Park and Del Mar.

The Del Mar titles were achieved in 1987 and 1988 with fifty-nine and fifty-four victories, respectively. Stevens recorded his first two stakes victories at Del Mar in 1985 aboard Tsunami Slew in the Eddie Read Handicap and First Norman in the Del Mar Derby. He also had stakes wins in 1986, but they were both of the Grade I variety, aboard Auspiciante in the Ramona Handicap and Qualify in the Futurity. Stevens would add four more Grade Is, most notably Pacific Classics with Bertrando in 1993 and Gentlemen in 1997. Bertrando was a wire-to-wire, three-length victory. Gentlemen faced only four rivals and outran his stablemate Siphon in a one-two finish for trainer Richard Mandella. Stevens hopped off to report that Gentlemen had done it without really feeling comfortable on the track, without his usual fluid stride and on his left lead for all but about fifty yards of the one-and-a-quarter-mile race.

Stevens's stakes victory total, 79, ranks seventh on the track's all-time list, and his win total, 563, ranked eighth through the 2010 season. In 1997, Stevens tied the track record for stakes victories in a season with 12, matching the number for Laffit Pincay Jr. in 1976 and Chris McCarron in 1995. Corey Nakatani would join the group with 12 in 1998, a season in which Stevens produced 11.

Injuries made Stevens less of a factor at Del Mar after 1998, and chronic knee problems would lead him to retire in 1999 to pursue other interests in racing. He would make a comeback a year later and win six stakes at Del Mar between 2001 and 2003, among them the Grade I Del Mar Debutante

in 2002. A gate mishap at Del Mar on July 28 had forced Stevens to submit his right knee to surgery for the eighth time on August 1. He was thirty days removed from the procedure and one day back in the irons when, at thirty-nine, he guided Miss Houdini to a $24.80 upset in the Debutante for eighty-year-old trainer Warren Stute. Fifty years earlier, Stute had won the Debutante with Tonga, and Miss Houdini's victory would prove to be the last of twenty-four, and the only Grade I at Del Mar, in Stute's more than half century of summers at Del Mar.

"I only bet forty dollars," Stute said. "If I'd have really liked her, I'd have bet a couple hundred." Stevens picked up the mount the morning before the race. Stute needed a rider because Eddie Delahoussaye had been injured in a spill a day earlier. "Warren and I go back a long ways together, and it's nice to know that he didn't even hesitate to put me on this filly," Stevens said. "I'm sure there are some skeptics out there [regarding his comeback], but I know myself pretty well. This feels awfully good. It's a great way to come back, winning a Grade I."

In 2003, Stevens was getting rave reviews for his portrayal of George Woolf in the movie *Seabiscuit* and sitting pretty with the mount on Candy Ride for the Pacific Classic. Then his injury in the Arlington Million created the opportunity Julie Krone seized to ride Candy Ride in the $1 million race. Stevens rode only the last six days of the 2004 meeting, returning from a five-month, only semi-successful sojourn in France as the stable rider for legendary French trainer Andre Fabre. It wasn't his first international venture; previous extended stints had him based in Hong Kong in 1995 and England in 1999.

As he prepared to leave France and return to the United States in 2004, Stevens was asked over the international phone line what he was most looking forward to when he got back to Del Mar. He didn't hesitate a second. "Mexican food," Stevens said.

CHARLIE WHITTINGHAM

Whittingham was a native son of San Diego, an icon of Southern California thoroughbred racing that the world recognized throughout the second half of the twentieth century and came to embrace and fully appreciate via Kentucky Derby wins with Ferdinand in 1986 and Sunday Silence in 1989.

But Charlie Whittingham was more than a Hall of Fame horse trainer. He was, by all accounts and any measure, a helluva man.

He was born in 1913 in Chula Vista, down close to the border with Mexico, the son of immigrant farm laborers from Yorkshire, England. As a youth, he followed an older brother, who was a jockey, to the Agua Caliente track in Tijuana, which was where the horse racing action was, the sport not being legalized in California until the 1930s. And, having grown too big and given up the idea of being a jockey himself, he was owning and training horses and present when Santa Anita opened in 1934, Del Mar in 1937 and Hollywood Park in 1938.

Whittingham was an assistant to legendary trainer Horatio Luro for a time before joining the marines at the outbreak of World War II. He achieved the rank of master sergeant, fought at Guadalcanal, lost a lot of his hair after contracting malaria and took to shaving his head and creating the look that got him the nickname "the Bald Eagle," which would become familiar to generations of racing followers. He reunited with Luro after the war but eventually went out on his own and commenced to win stakes races by the score in Southern California, trained ten U.S. champions and won Eclipse Awards in 1971, 1982 and 1989 while charming and/or impressing everyone he met.

The Del Mar statistics are 281 wins in 41 seasons, seventh overall, and 74 stakes wins, which still held second on the list through the 2010 season. All but two of Whittingham's stakes victories were recorded between 1968 and 1996. His place atop the list for stakes victories by a trainer would stand for a decade before being surpassed by Bob Baffert.

Winning the same stakes race multiple times, a Whittingham trademark everywhere on the Southern California circuit, was reflected at Del Mar with nine victories in the Ramona Handicap, including four straight from 1991 to 1994, seven wins each in the Del Mar Oaks, Del Mar Handicap and Palomar Handicap; five wins in the San Diego Handicap; and four each in the Chula Vista and El Cajon Handicaps. The Pacific Classic came too late for Whittingham and his lone entrant, Anshan, in the 1991 inaugural, which finished seventh of eight at odds of twenty to one under Gary Stevens.

In the summer of 1985 at Del Mar, Whittingham showed Bill Shoemaker a colt named Ferdinand and remarked about the great promise he felt the lanky chestnut two-year-old had for the future. That promise wasn't evident to anyone else in Ferdinand's racing debut at Del Mar on September 8, an eighth-place finish of eleven in a six-furlong maiden event. But Ferdinand's potential was revealed as the distances got longer, and on May 3, 1986, given a masterful ride by Shoemaker after a troubled start, Ferdinand made

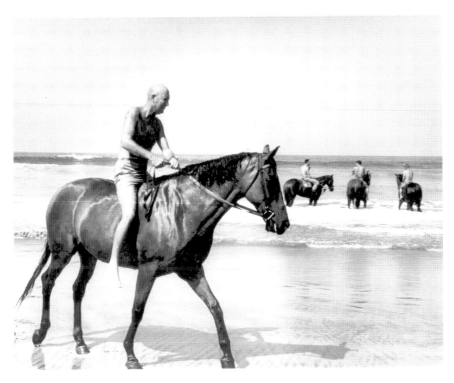

Training legend Charlie Whittingham was a believer that salt water was good for horses' legs and, in the early years at Del Mar, practiced what he preached. *Courtesy DMTC.*

Whittingham, seventy-three, and Shoemaker, fifty-four, the oldest winning jockey-trainer combination in Derby history. It was Whittingham's first Derby starter in twenty-six years.

"Never winning the Derby didn't make me want to shoot myself. I won races everywhere," Whittingham said. "But everybody knows the Kentucky Derby. You say, 'Geez, I did do a hell of a thing.'" In August 1987, Ferdinand raced again at Del Mar, winning the Cabrillo Handicap by two lengths under Shoemaker.

On May 6, 1989, Sunday Silence, ridden by Patrick Valenzuela, won the Kentucky Derby to extend Whittingham's oldest trainer standard to seventy-six. Unlike Ferdinand, Sunday Silence never raced at Del Mar. But following his victory in the Preakness, and runner-up finishes in the Belmont Stakes at Belmont Park and Swaps Stakes at Hollywood Park, Sunday Silence was brought to Del Mar to train for his fall campaign of 1989. On a sweltering summer afternoon, the Del Mar crowd watched Sunday Silence, under Valenzuela, work a mile between races in just over 1:33, approaching the track record at the time. Those who saw it weren't surprised when the black colt that Whittingham not only

trained but also part owned went on to finish the year with a six-length romp in the Super Derby at Louisiana Downs and conquer Easy Goer for the third time in four matchups in the Breeders' Cup Classic to cinch Horse of the Year honors.

Whittingham's death on April 20, 1999, at age eighty-six, was met with sadness in the Del Mar community, as it was everywhere in racing. "There will never be another Charlie Whittingham, ever," trainer Gary Jones said. "He left no stone unturned when it came to preparing a horse to run, and he was probably the most logical person I've ever known."

"A great thing about Charlie was his ability to handle horses and people," said retired jockey Don Pierce. "He had the greatest personality as far as talking to his owners, jockeys, the media, anybody and everybody around the track. He handled every situation very well."

"He was one of the great ones," said Joe Harper, who became the head of track management at Del Mar in 1977. "Probably more horse than man, and he sure livened up the Del Mar meet for all of us. I'll never forget how he'd see me for the first time before a meeting and always put his arm around me, say, 'Glad you're around here' and then give me a head butt. He was all marine, a great character and one heck of a horseman."

On July 31, 1999, the Charlie Whittingham Sports Pub, located off the northeast corner of the paddock, was dedicated. It was designed by his daughter, Charlene, and included 175 pictures of Charlie, plus trophies and placards with some famous Charlie-isms: "He who hoots with the owls by night can't soar with the eagles by day." "I taught him everything he knows about training, but I didn't teach him everything I know."

Charlie's son, Michael, also a trainer, represented the family and addressed the assembly wearing a hat that was among the last his father had worn. "This is a nice thing," Michael said. "He's a hometown boy, and it's nice that we have this remembrance. We in the family all miss him, and it's nice that we can come in here and visit. It's nice of Del Mar to do this."

D. WAYNE LUKAS

In 1978, a trainer in the first year of a transition from quarter horses to thoroughbreds served notice at Del Mar of things to come, winning the Eddie Read Handicap with Effervescing and the Debutante with Terlingua. And oh, what things were to come in the next decade-plus for Darrell Wayne Lukas.

Del Mar may have been only one of many tracks Lukas dazzled while rapidly expanding the size and scope of his operation and essentially taking the industry by storm. But it was a major one, and the accomplishments at Del Mar contributed mightily to Lukas topping the national training list for earnings from 1983 to 1992 and 1994 to 1997 and leading the standings for wins from 1987 to 1990 and stakes victories from 1985 to 1992.

He always came to Del Mar with a strong group of two-year-olds, especially fillies. Terlingua was the first of nine Debutante winners for Lukas, seven of them between 1982 and 1989. Althea (1983) and Lost Kitty (1987) even followed up Debutante victories by beating males in the Futurity to put an emphatic Lukas stamp on the end of those meetings. Lukas won or shared Del Mar training titles in 1982, 1987–88 and 1990.

A watershed moment in Del Mar and racing history came at the track in 1982, when Lukas met Gene Klein, owner of the NFL's San Diego Chargers and a resident of nearby Rancho Santa Fe. Klein's wife, Joyce, was the first to develop an interest in horse racing. After meeting Lukas, however, Gene Klein entered the game with the same enthusiasm and huge commitment he had his previous successful enterprises in car sales, the entertainment business and the NFL franchise. His commitment became especially strong after he sold the Chargers to Alex Spanos in 1984.

In seven years, in combination with Lukas, Klein would experience: Triple Crown race victories in the Preakness (Tank's Prospect, 1985) and Kentucky Derby (Winning Colors, 1988); seven victories in Breeders' Cup races; a Horse of the Year–winning campaign (Lady's Secret, 1986); back-to-back Eclipse Awards for Open Mind in the two-year-old and three-year-old filly divisions in 1988 and '89; and Eclipse Awards as the national champion owner from 1985 to 1987.

Klein built the Rancho Del Rayo Stables on 237 acres a few miles inland from the racetrack and established the D. Wayne Lukas Training Center there, which initially was intended for the stock he and other ownership clients had with the trainer.

But in 1989, Klein announced his intention of getting out of the thoroughbred business and did so via a dispersal sale at Keeneland in Lexington, Kentucky, in November of that year. The sale encompassed 114 horses and grossed $29,623,000, with the top sellers being Open Mind ($4.6 million), Winning Colors ($4.1 million) and Lady's Secret ($3.8 million in foal to Alydar). Klein's death would come only four months later, in March 1990.

Of the combined eighty-three lifetime starts by Klein's "Great Ladies of Racing" trio, only one was at Del Mar, a fourth-place finish by Lady's Secret

in the 1984 Junior Miss Stakes. The top Del Mar years for the Lukas-Klein combination were 1982 and 1987. In 1982, Klein was part owner of Lukas-trained Saratoga Six, which won the Balboa Stakes, and Futurity. In 1987, Lukas-Klein-co-owned Lost Kitty took the Debutante and Futurity to make them the leading owners for the meeting.

On the eve of their final Del Mar go-round in 1989, Lukas reflected on the partnership that was months from being dissolved. Lukas said the relationship might have been unique because of their backgrounds in sports—Lukas as a former basketball coach, Klein as the former Chargers owner. "We thought alike, we approached the game alike and we both had that killer instinct when it came to competition," Lukas said.

> *He won a little better than he lost, and he got caught up in the moment on occasion. But I never trained for anybody who took hardships better than this guy.*
>
> *He was definitely good for me, but he was also good for racing…He was one of the few guys who stepped up and said you can go and buy what* [major breeders] *are offering at the sales and beat them at their own game…His contribution to racing is going to be that he showed you can rear back and go at racing with gusto and make it big.*

The loss of Klein as a client, the acquisition of other major clients based east of the Mississippi and his eventual disillusionment with California racing would diminish Lukas's Del Mar presence, and he would, by the early 2000s, be entirely headquartered in Kentucky and New York. Of Lukas's forty-eight stakes victories, tied for fifth on the track's all-time list through 2010, thirty-two were achieved in the 1980s. His last of three Grade I wins at the track came, appropriately enough, in the 1996 Debutante with Sharp Cat.

RON MCANALLY

The southernmost end of the barn traditionally assigned to trainer Ron McAnally at Del Mar is less than fifty yards from the portion of the track where the horses, having rounded the clubhouse turn, straighten out for the run to the five-eighths pole. The upper-level balcony, outside the stable crew living quarters, affords a good view of the track and serves McAnally as a private viewing stand for morning workouts.

It's a vantage point befitting the man who tops the track's list for training victories, with 434 in fifty-one seasons through 2010, and ranks third for stakes victories, with 73, one behind Charlie Whittingham. It was the place where, in 2003, McAnally watched Candy Ride blaze through his final workout for the Pacific Classic, covering a mile in just over a minute and thirty-six seconds, and called out the intermediate splits that were verbally relayed down a line of followers that included owners Sid and Jenny Craig and Ted Aroney, the Craigs' stable manager.

Candy Ride's victory was the fulfillment of a quest by Sid Craig to win the biggest race of the season at his hometown track and the high point in a long relationship with McAnally that had a lot of them. "It's the most exciting moment in my racing career," Sid Craig said afterward. "More than winning the Epsom Derby [English counterpart to the Kentucky Derby], more than the Breeders' Cup. It doesn't get any better than in your own back yard."

McAnally was born in 1932 in Covington, Kentucky, and was raised in a northern Kentucky orphanage with two younger brothers and two sisters after his mother died. He served in the U.S. Air Force and spent two years as an electrical engineering student at the University of Cincinnati, but his uncle Reggie Cornell, who later trained the come-from-behind legend Silky Sullivan, provided entree into the sport and profession of McAnally's life. He recorded his first victory in California at Hollywood Park in 1958, his first stakes victory at Santa Anita in 1960 and his first stakes victory at Del Mar in the 1961 California Thoroughbred Breeders' Association Stakes with Donut King, for owner Verne Winchell of the Winchell's Donut chain.

He would visit the winner's circle after stakes races at least once in each of thirty-seven Del Mar meetings from 1961 to 2008 and put together streaks of ten (1977–86) and nineteen (1988–2006) years in a row. The numerical high points were five stakes wins in 1978 and 1993. Five other summers produced four stakes victories.

McAnally won Del Mar training titles twice, the first in 1980 with fourteen wins and the second in 1989, when his seventeen victories from eighty-one starters (21 percent win rate) were three more than those of D. Wayne Lukas and Charlie Whittingham. The following winter, McAnally was voted into the racing Hall of Fame and came to the 1990 Del Mar meeting with an induction date late that summer. "For the most part, it's been our turn down here," McAnally said. "Del Mar has been one of the luckiest meetings for the stable. It just seems that over the last thirty years, we've had some fantastic meetings. Who knows why you have a good meet, it just happens."

McAnally's entry into the Hall of Fame would coincide with that of John Henry, the modestly bred gelding McAnally trained to twenty-seven wins in forty-five starts in a career that would produce thirty-nine victories in eighty-three starts, over $6.5 million in earnings and Horse of the Year honors in 1981 and 1984. While John Henry never raced at Del Mar, it was the place McAnally used to train for big races like the Arlington Million, where victories in the 1981 inaugural and again in '84 secured Horse of the Year titles.

Two other McAnally trainees that would gain Hall of Fame entry, Argentine-import females Bayakoa and Paseana, did race at Del Mar, albeit with mixed results.

Bayakoa, owned by Mr. and Mrs. F.E. Whitham, garnered Eclipse Awards as the top older mare in 1989 and 1990 and was inducted into the Hall of Fame in 1998. She ran at Del Mar five times between 1990 and 1998. Bayakoa was fifth of six in her Del Mar debut in the 1988 Osunitas Stakes and then came back to a romping ten-length victory in the June Darling. Last of six in the 1989 Chula Vista, Bayakoa was back in 1990 to finish second against males in the San Diego Handicap and then pull out a nose victory in the Grade II Chula Vista while conceding fourteen pounds in the weights to runner-up Fantastic Look. Paseana, owned by the Craigs, was voted the top older mare in 1992 and 1993 and was inducted into the Hall of Fame in 2001. Paseana, entered against males in pursuit of Sidney Craig's Pacific Classic dream in 1992, came home fifth of seven but was back two years later against her own sex to produce a nose victory in the Chula Vista.

His work with John Henry, Bayakoa and Paseana helped boost McAnally to Eclipse Awards as the top trainer in 1981, 1991 and 1992. Longtime Del Mar followers may also recall the names of some of his eight horses that were multi-time stakes winners at the track—horses like Luz Del Sol, a double winner in the 1960s; Drama Critic, a triple winner in the '70s; Syncopate, winner of the 1979 and '81 Bing Crosby Handicaps; Hawkster, a double winner in the 1980s; Tight Spot, a three-timer in the 1990s; and Sweet Return, a double winner in the 2000s.

Chances are, no matter how many more wins and stakes victories McAnally rings up at Del Mar, however, the 2003 Classic, in which Candy Ride established a track record of 1:59.11 for one and a quarter miles, will remain atop his list, despite the fact that it was the last race for Candy Ride before retirement due to a ligament injury.

"To me, he was the best horse in the world at that time," McAnally would say a year later. "He was so competitive. He didn't need the right pace. And his [running] action was just flawless. To me, there was not a horse in the world that could beat him. None."

The 1950s–1970s

Little Big Men

In 1949, a young rider out of Texas set a Del Mar track record of fifty-two wins at the meet to become the first apprentice to claim the track's riding title. Bill Shoemaker's emergence would set the scene for an era in which Shoemaker and two other men of diminutive stature, jockey John Longden and trainer Farrell Jones, would mark milestones and register major accomplishments at the track that would forever be noted in their distinguished careers.

As the second half of the twentieth century began at Del Mar, the trainer on the biggest roll was Robert Hyatt "Red" McDaniel. From 1950 to 1954, McDaniel won meet training titles, recording thirty-one wins in 1950 and increasing the total to thirty-two in 1951 and '52, thirty-six in 1953 and forty-seven in 1954. McDaniel, a native of Enumclaw, Washington, was a contemporary of Longden who left the family dairy farm as a teenager to become a jockey, notching his first win at age fifteen, and did so with moderate success until a broken leg suffered at age eighteen moved him to other racetrack jobs. He worked at Agua Caliente and at Rancho San Luis, among other places, and as a jockey agent for Noel Richardson, Jack Westrope and Red Pollard before gaining success as a claiming trainer starting in the 1940s.

McDaniel was among the first to recognize the talents of Shoemaker, and their partnership bloomed in the early 1950s. Of McDaniel's forty-seven wins in the forty-one-day Del Mar meet in 1954, still the track record for a trainer, forty-two came after giving Shoemaker a leg up into the irons.

The previous year, 1953, McDaniel was the leading trainer at six different California courses—Santa Anita, Tanforan, Hollywood Park, Del Mar (thirty-five wins), Golden Gate and Bay Meadows.

On May 5, 1955, about 4:35 p.m., McDaniel stopped his car mid-span and jumped to his death from the San Francisco Bay Bridge. He was forty-four years old and in the previous five years had recorded more victories than any trainer in North America, in addition to becoming the first to win two hundred in a year, in 1953. The previous February, he had won the Santa Anita Handicap, the biggest race in California, with Irish-bred Poona II. No suicide note was found. No definitive reason was ever offered by friends and family.

Easily the most celebrated horse of the 1950s–1970s at Del Mar was Native Diver, the winner of the San Diego Handicap from 1963 to 1965 and the Del Mar Handicap in 1967.

Native Diver only raced once outside California in a seven-year career started in 1961 but gained matinee idol status in the Golden State with thirty-seven victories from eighty-seven starts and earnings of $1,026,500—the seventh million-dollar earner in racing history and the first California-bred horse to achieve seven-figure status. Thirty-four of the victories were in stakes races. Owned by Mr. and Mrs. Louis K. Shapiro, Native Diver lost three of his four Del Mar starts in 1962 and '63, all in stakes and all ridden by Ralph Neves. The lone victory, in 1963, was in the San Diego Handicap, the event Native Diver would take again in '64 and '65 in his only Del Mar starts while guided by Jerry Lambert. Still racing at age eight, with his connections having vowed to retire him at any sign of a slowdown, Native Diver won the 1967 Del Mar Handicap under Lambert by three lengths in track record time of 1:46.60 for one and one-eighth miles. Eight days later, Native Diver fell ill with colic and was taken to the equine hospital at U.C. Davis, where he died a day later.

THE PUMPER AND THE SHOE

John Longden and Bill Shoemaker tied for the Del Mar riding title in 1950 with sixty wins each, establishing a connection to each other and the track that would span the decades. They would both win multiple Del Mar riding titles. They would be inducted into racing's Hall of Fame in 1958. They

Arrogate (inside), with John Longden up, won the Del Mar Handicap on Labor Day 1956, providing Longden his 4,871st career victory and establishing a world record. *Courtesy DMTC.*

would both become the all-time victory leaders in their professions in races at Del Mar. They would both saddle stakes winners at Del Mar as trainers following retirement from riding. And their passings in 2003—Longden on February 14, his ninety-sixth birthday, and Shoemaker on October 12, at the age of seventy-two—were both felt deeply at Del Mar.

Shoemaker arrived on the Del Mar scene as a nineteen-year-old apprentice in 1949, his maiden victory not far behind; he proceeded to win a record fifty-two races and became the first apprentice to claim the riding title of a Del Mar meeting. After tying with Longden for the title in 1950, Shoemaker was the solo champion from 1951 to 1954, recording steadily increasing win totals of forty-six, fifty-six, seventy-four and ninety-four in 1954, a record approached only once since, with Laffit Pincay Jr.'s eighty-six in 1976.

Shoemaker was not a regular at Del Mar from then until 1969, and in his absence, Longden recorded his second and third riding titles in 1956 and '58, totaling seventy-three wins in 1956, the fifth highest of all time behind two each for Shoemaker and Pincay.

Bill Shoemaker guides Dares J. to victory on Labor Day 1970, in career victory number 6,033, to become racing's all-time win leader. *Courtesy DMTC.*

On Labor Day 1956, Longden, nicknamed "The Pumper" for his style of riding high on a horse's neck and pumping his arms, booted home Arrogate in the Del Mar Handicap for victory number 4,871 to surpass Sir Gordon Richards as the world's winningest rider. He hopped off to be greeted in the winner's circle by his family and dignitaries, including Desi Arnaz, and addressed the crowd over the public address system with a wreath bearing the number 4,871 draped over his shoulders.

Longden was born in England but came to Canada with his family at age four. "We had reservations to come over on the *Titanic*," he said. "We missed the boat somehow." He left the coal mines of Taber, Alberta, Canada, to become a jockey, rode Count Fleet to the Triple Crown in 1943 and became the only person to ride and train a Derby winner when he saddled Majestic Prince to Derby and Preakness victories in 1969.

Longden rode for ten years after breaking Richards's record and retired in 1966 with 6,032 victories from 32,413 mounts, an 18 percent win rate. On September 7, 1970, Shoemaker, having returned to Del Mar, guided a filly named Dares J. to victory for career victory number 6,033. Longden was on hand to congratulate Shoemaker afterward.

In 1987, Shoemaker rode Swink for Hall of Fame trainer Charlie Whittingham to victory in the Del Mar Handicap in track and stakes record time of 2:13.80 for one and three-eighths miles on the turf course. It would be the last of ninety-four stakes victories at Del Mar for Shoemaker, who remained among the top five overall through 2010. Having announced his upcoming retirement and partially completed a worldwide farewell tour, Shoemaker made his last ride at Del Mar on September 10, 1989, guiding Addie's Bro to victory in the ninth and final race of the day.

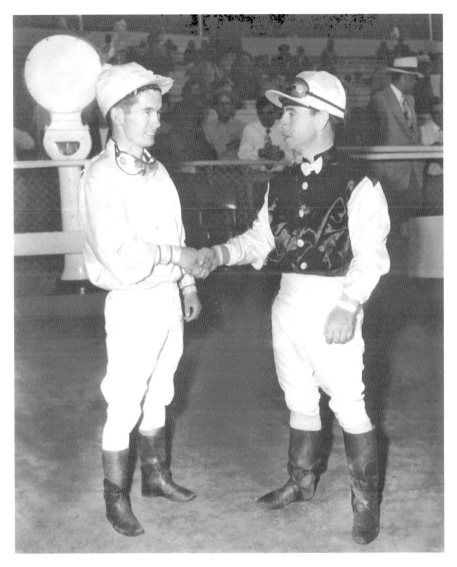

Two of the all-time greats, Bill Shoemaker (left) and John Longden shake hands after tying for the 1950 Del Mar meeting riding title with sixty victories each. *Courtesy DMTC.*

Shoemaker, fifty-eight, kept the four-year-old colt close to the lead throughout and prevailed by two lengths in 1:42.60 for one and one-sixteenth miles. He returned to the winner's circle on Addie's Bro to shouts of "Shoe, Shoe!" from many among an on-track turnout of 20,861 who had stayed until sunset to watch Shoemaker's final Del Mar ride. "I want to thank all the fans. I hope they think I've given them all I've got, which I have," Shoemaker

had said in a ceremony honoring him earlier in the afternoon. "Thanks for putting up with me for forty years."

Mike Mitchell, who trained Addie's Bro for owner L. Dean Harrington, said afterward that he was "just happy to get Bill in the winner's circle" after the legendary rider had gone zero for three with earlier mounts on the card. Mitchell didn't have a lot of instructions for Shoemaker before the race. "Mike just said this horse had to have the lead—but he didn't have the lead, did he?" Shoemaker said.

Shoemaker hustled Addie's Bro to the front out of the gate, but Ray Sibille on Crystal Cutter, an eight-to-one shot, charged up alongside. Crystal Cutter had a head in front at the half-mile and six-furlong poles. "My horse just ran off with me," Sibille said. "If he had rated a little better we might have had a chance to win. When we got up there down the backstretch, I thought 'Oh man, I hope I don't cost Bill the race.'"

Shoemaker went on to record 8,883 career victories, 889 of them at Del Mar. His stakes victories numbered 1,009, with 250 of them in races worth $100,000 and upward. He would hold the record for career victories for nearly ten years and would be on hand to congratulate Laffit Pincay Jr. when it was broken on December 10, 1999, at Hollywood Park.

Longden went into training soon after his retirement from riding and counted five stakes victories at Del Mar, the most prestigious being the 1967 Futurity with Baffle. Shoemaker's stakes victories at Del Mar as a trainer came with Baldomero in the 1990 Osunitas Handicap and Diazo in the 1993 Relaunch Handicap.

FARRELL JONES

From 1960 to 1974, Farrell Jones won eleven of a possible fifteen Del Mar training titles. He strung together seven in a row from 1960 to 1966, a record that Bob Baffert matched from 1997 to 2003. Jones then won three straight from 1969 to 1971 and added an eleventh title, for good measure, in 1974.

"Everything I went to Del Mar with in those days turned out good," Jones said in an interview in the summer of 2003, four years before his death at age eighty-four. "My barn was right at the end of the stretch, and I really believe that my horses coming down there thought they were going for home. When they turned at the head of the lane, they were looking right at that barn. It's

the truth, and I believe it to this day. People laugh at you, but I tell you one thing, if I went back I'd want that same barn."

Jones, whose son Gary and grandson Marty would follow him into training and stakes victories at Del Mar, won 374 races in twenty-two seasons at the track, still number three overall through 2010. The award that goes annually to the top trainer of the Del Mar meeting is the Farrell Jones Award. His 20 stakes victories between 1959 and 1975 included multiples in the La Jolla Mile (4), Del Mar Derby (3), Del Mar Oaks (2), Oceanside (2) and Osunitas (2).

And while he had been retired from training for twenty years by the summer of 2003, Jones, who was managing a thoroughbred rest and recuperation center in Hemet, California, was the strongest living link between Del Mar and Seabiscuit, the horse that put the track on the national map with the 1938 match race against Ligaroti and was the subject of newly kindled public interest via a book and movie. Jones, who started riding at age nine in his native Idaho, had come to California at thirteen, weighing barely more than eighty pounds, and signed an apprentice contract with the stable of Seabiscuit owner Charles S. Howard. Jones, who exercised Seabiscuit but never rode him in a race, was closely connected to Howard, trainer "Silent Tom" Smith and Red Pollard, the regular rider of the "Biscuit."

Jones was not portrayed in the movie but was referenced six times in Laura Hillenbrand's bestselling book and received a letter of appreciation from Hillenbrand for his contributions provided in telephone interviews. Jones was at Saratoga in August 1936 when Seabiscuit was led from the barn of legendary trainer "Sunny" Jim Fitzsimmons to the Howard stable, where Smith awaited.

"It's in the book that I said, 'Looks like they got another saddle horse,'" Jones said. "That's the truth. I said that. He [Seabiscuit] was quiet and nothing bothered that horse…But that sumbitch was a good, good horse, Seabiscuit was…At equal weights, I think in his prime he would run with the best horses going today…And let me tell you, that statue of him in the paddock at Santa Anita is exactly the way that horse was."

1937–1950

From the Start

The story of the genesis of Del Mar, from an idea pitched to Bing Crosby, one of the most popular and powerful Hollywood stars of the time, to Opening Day on July 3, 1937, was told by internationally known author and Del Mar racing enthusiast William Murray in *Del Mar, Its Life and Good Times*, first issued in 1988. It is retold here with permission from Murray's editor and Del Mar Thoroughbred Club senior media coordinator Dan Smith.

HOLLYWOOD BEGINNING

Crosby had bought part of the historic Don Juan Osuna Ranch in Rancho Santa Fe and had moved in by the time the 22nd District Agricultural Association began to build a fairgrounds on the present site that was to include a grandstand and a one-mile racetrack. A sportsman named William A. Quigley, then living in La Jolla, knew that Crosby loved horse racing and thought that he might want to form a syndicate to put on a meet in Del Mar.

Crosby was enthusiastic. He immediately summoned a number of his Hollywood cronies to a meeting at the Warner Brothers studios in Burbank and organized the Del Mar Turf Club, with himself as president, his brother Everett as secretary-treasurer and Pat O'Brien and Oliver Hardy as officers. Also on the executive committee were Joe E. Brown, Gary Cooper and other

Founding upper-level management. *From left*: General Manager Bill Quigley, President Bing Crosby and Vice-President Pat O'Brien. *Courtesy DMTC.*

prominent figures. Stock in the operation cost $100 a share and a 10-year lease was signed with the 22ⁿᵈ Ag District.

Unfortunately, the project, partly financed by federal Works Progress Administration funds, soon ran out of cash. Crosby and O'Brien borrowed money against their life insurance to finish the facilities, which didn't seem to faze the crooner a bit. Nothing ever ruffled Crosby, and he had surrounded himself with similarly unflappable, well-heeled and glamorous players.

Opening Day, July 3, 1937. Track founder Bing Crosby greets Mrs. W.R. Richardson, the first patron through the gates. *Courtesy DMTC.*

By the time the opening of the first 22-day meet came around on July 3, 1937, a lot of the paint on the premises was still a little wet, but at least a roof had been put on the grandstand and the horses were ready to run. About 15,000 people showed up on opening day, and Crosby and O'Brien were there in person to greet the first arrivals at the turnstiles. Crosby was dressed in his familiar costume of floppy sports shirt and yachting cap, though he later donned a bright blue jacket, white slacks and a straw boater for the official opening ceremony in the infield. "We hope you all enjoy the meeting—and have a measure of success at the payoff windows," he told the crowd in his best informal style.

The first race was late getting underway. The special train that the Santa Fe Railroad had dispatched, loaded with plungers from L.A., was late. When it finally appeared, through a gap in the hills just north of the track, everybody cheered. Cheering for the train, whether it was late or not, subsequently became a Del Mar tradition, which survived until the service was discontinued in the mid-60s. Finally, when all the late-comers had placed their bets, the first race went off at 2:24 p.m. A gelding named High Strike led all the way to win, which might have made some people

Cars pack the parking lot on race days during the inaugural season, 1937. *Courtesy DMTC.*

suspicious, since the animal happened to be owned by Mr. Crosby himself. But apparently it didn't, because everybody cheered even louder than before. It was an auspicious beginning, and when 18,000 people showed up on the second day, betting nearly a quarter of a million dollars on their selections, everybody assumed big-time racing had come to Del Mar to stay.

Attendance dropped off drastically after those first few days, however, and Del Mar ultimately attracted an average of fewer than five thousand patrons a day. That trip down from L.A. turned out to be, in Oscar Otis's words, "a torturous hundred miles." The trains were slow, the roads poor and the airlines nonexistent. In the long run, the difficulty of the trip and the limited patronage Del Mar attracted probably saved it by allowing its relaxed, old-fashioned air to be retained. Del Mar's remote location, like Saratoga's in upstate New York, preserved it for those who liked to think of horse racing as something a little classier than a crap game.

Putting Del Mar on the Map

The event that, by all accounts, either "made" Del Mar or at least put it on the worldwide racing map was the match race on August 12, 1938, between Seabiscuit and Ligaroti.

Seabiscuit, a five-year-old son of Hard Tack and grandson of Man o' War, was the reigning handicap champion of the West and had won twenty-eight of seventy-nine starts over a four-year span. Owned by Charles S. Howard, a Del Mar director, Seabiscuit had become nationally famous for his heart and was a rags-to-riches inspiration in an America still recovering from the Great Depression. Seabiscuit was fresh from winning the inaugural Hollywood Gold Cup when Del Mar general manager Bill Quigley proposed the match race with Ligaroti.

Ligaroti was a recent import from Argentina, a six-year-old that had displayed great class in South America and was being touted as a top distance horse. Ligaroti was owned in partnership by Bing Crosby and Lin Howard, the trainer of Ligaroti and son of Charles Howard. The conditions were one and one-eighth miles for a $25,000 winner-take-all purse with Seabiscuit to carry 130 pounds and be ridden by George "the Iceman" Woolf and Ligaroti to carry 115 pounds with Noel "Spec" Richardson up.

Seabiscuit (A) has a slight lead over Ligaroti (B) in the final strides of the 1938 match race that put Del Mar on the national map. *Courtesy DMTC.*

Trainer "Silent Tom" Smith prepares to lead Seabiscuit and jockey George Woolf to the winner's circle after the match race victory. *Courtesy DMTC.*

To make it a true sporting match, no public wagering was offered. A record twenty thousand fans showed up on the day of the race, and untold thousands more listened to the nationwide NBC radio broadcast, which featured Crosby and Pat O'Brien on a microphone on the roof of the grandstand. Crosby enlisted Hollywood friends by the score to come down for the event and had a special section of the grandstand reserved for Ligaroti backers, replete with college-style cheerleaders in "L" sweaters to organize vocal support.

At the break, under the guidance of starter Fred Cantrell, Seabiscuit came out first and had a half-length lead on his challenger by the first turn, but Ligaroti drew to within a head of him and stayed there all the way around. As the horses hit the stretch, the riders began to engage in a duel of their own. "That was as rough a race as I've ever seen in my whole life," sports writer Oscar Otis remembered. "They were hitting each other over the head with their whips, and Richardson had Woolf in a leg-lock. Never seen so much trouble in one race, and there was a hell of a stink about it."

Seabiscuit won by a nose in 1:49, which broke the track record by four full seconds, but the result had to withstand an inquiry immediately posted by stewards. The order of finish was allowed to stand, but the stewards were so angry that two days later they suspended both jockeys for the rest of the meeting and recommended to the California Horse Racing Board that the suspensions be continued through the rest of the year.

On August 18, six days after the race, both the *San Diego Union* and the *Evening Tribune* printed in full a statement issued by the stewards, at the request of the California Turf Writers Association, regarding what happened in the race. The key passage read:

> *Both boys went to the whip at the eighth pole and at this point Ligaroti had a tendency to lug in. Coming to the sixteenth pole Seabiscuit started to move on but jockey Richardson reached out and held on to* [Seabiscuit's saddle cloth] *until he was practically to the 70-yard pole, where Ligaroti had moved up considerably. At this point he let go of the saddle cloth and tried to grab jockey Woolf's wrist. Woolf fought to get his arm loose and about 20 yards from the finish line reached out and grabbed Ligaroti's bridle rein and held on to it from there across the finish line. It was the unanimous opinion of the stewards had no foul occurred Seabiscuit would have been the winner.*

The CHRB later ruled that since there was no betting on the race, and the public had therefore not been defrauded, the jockeys' suspensions should be lifted. In providing Del Mar with a watershed moment, Seabiscuit and his human connections—Howard, Woolf and trainer "Silent Tom" Smith—advanced their own legends and provided momentum for the more heralded match race Seabiscuit would win over War Admiral seventy days later at Pimlico.

Pre- and Postwar

By the end of Del Mar's second season, Crosby and his partners appeared to have made a sound investment. The 1938 meet, bolstered by the Seabiscuit-Ligaroti match race, drew 161,485 bettors through the gates in a twenty-five-day season, and the parimutuel handle rose to $3,920,251. The next two years, though, were disappointing, and at one point, steeplechase races were carded in the infield to stimulate interest. By the end of 1940, however, the daily handle had risen again, to an average of $192,075, and then 1941 turned out to be a banner year. The nation's rearmament program was turning San Diego into a boomtown, with local defense plants on twenty-four-hour shifts. A lot of this money found its way into the betting windows, and the average daily handle for the thirty-two-day meet rose to $245,393.

All this came to an end when the country went to war on December 7, 1941. First the facilities were used as training quarters for the marines and then the Del Mar Turf Club Aircraft Division was formed and assembly lines were set up in the grandstand to manufacture wing ribs for Douglas B-17 bombers. Bill Quigley died in March 1942, and Willard F. Tunney succeeded him. There were, of course, no race meetings in 1942 and '43. In 1944, with the end of the war in sight, Tunney tried to get racing dates that summer but failed. It wasn't until 1945 that Del Mar reopened, on July 11, with a forty-day meeting. On August 14, when news of Japan's surrender came during the course of the day's card, Pat O'Brien himself made the announcement. "Although this is a time for joyous celebration," he said, "it is even more time for prayerful thanks." A priest proceeded to deliver a public prayer for the men and women of the armed forces and asked for five minutes of respectful silence. The pause was succeeded by a celebration of epic proportions. The next day, a national holiday proclaimed by President Harry Truman, 20,324 fans stormed the gates and wagered $958,476, a new Del Mar record. The season as a whole was a great success with the handle up nearly $24 million, over three times the 1941 total.

To make up for the three years lost to the war, the Twenty-second District extended the original lease and granted a new one for an additional ten years, to December 31, 1959. After nine years, Crosby and O'Brien were finally able to recoup their original loans, amounting to almost $600,000 without interest, and the future of the operation seemed ensured.

Track Management, from Bing to Joe

In early 1946, rumors began to circulate that Crosby was about to leave the Del Mar scene. On April 17, it was announced that Bing had sold his stock to Arnold M. Grant, a New York and Beverly Hills lawyer. Crosby's move was apparently dictated purely by business considerations, and he was joined in selling out by O'Brien and Charles Howard. Nevertheless, the show business flavor of ownership remained, with Mike Todd, a prominent producer of stage and screen extravaganzas, as a member of the board of directors. A small, chunky man with a cigar permanently clamped between his teeth, Todd was not one to shy away from innovations. He proposed to stage a gigantic water ballet in the infield between races to keep the fans amused, but the project was vetoed as too costly. Instead, in the first year of the new ownership, a book containing several of Damon Runyon's best short stories about the track entitled *All Horse Players Die Broke* was passed out free to patrons on opening day. It seemed a dubious way to welcome them to the races, but it didn't dissuade anyone from betting.

The 1946 meeting was a success, but Grant's administration was not an unqualified triumph. He made changes that alienated many of his supporters, as well as the fans, and in 1948, the ownership of the lease passed to a third group of investors, headed by Joseph M. Schenck, the head of National Theaters Inc., and Jay Paley, one of the original owners of CBS. The abruptness of these changeovers led to a column by Ned Cronin, a sports writer for a Los Angeles paper, labeling Del Mar as "Capital Gains Downs." It proved to be prophetic because ownership of the corporation changed four times in six years.

On June 11, 1954, control of racing at Del Mar passed into the hands of a couple of wealthy Texans, Clint Murchison and Sid Richardson. *Time* magazine reported they were buying a 40 percent controlling interest for $1.2 million. Murchison and Richardson announced they had bought their shares in order to benefit a charity they had set up known as Boys Incorporated of America. The organization would use its earnings to combat juvenile delinquency, but only after the original shareholders had been paid off.

Headquarters for the Texas owners was the Hotel del Charro they owned in nearby La Jolla, which had opened in 1953. Murchison and Richardson were well known for currying favor with politicians and the power elite in many other fields of endeavor. Their comped hotel guests during their Del Mar ownership included FBI director J. Edgar Hoover, who was said to be more powerful than the president of the United States, and Senator Joseph

FBI director J. Edgar Hoover spent many summer racing days at Del Mar. Here, he is shown with members of a jockey colony that included John Longden, on Hoover's right, and Bill Shoemaker, on his left. *Courtesy DMTC.*

McCarthy of Wisconsin, who stayed there in 1953 and '54 on breaks from his anti-Communist hearings.

In September 1953, a few days after McCarthy spent time with Hoover and his hosts playing the ponies at Del Mar, he hauled a bookie before his committee regarding bets being taken in the Government Printing Office. Hoover was rumored to have influenced the Murchison-Richardson takeover of Del Mar, and at a June 11, 1954 press conference at the Beverly Wilshire Hotel in Los Angeles, where the official takeover announcement was made, Hoover's name was announced as a possible head of Boys Inc. whenever he saw fit to retire from the Federal Service. That, of course, never happened. Hoover, accompanied by his second in command, Clyde Tolson, made West Coast summer trips annually for physical checkups at nearby Scripps Clinic and would go to the track a couple times a week to while away the afternoons in a special reserved box. He was reportedly strictly a two-dollar bettor but loved the races.

The non-local background of Murchison and Richardson, the suspicious nature of their dealings and questions about the Boys Inc. arrangement did nothing to promote popularity. And their image took a major hit with the resignation of Marine Corps general Holland "Howlin' Mad" Smith as president of Boys Inc. General Smith lived up to his nickname when he found he wouldn't have any funds immediately to build a clubhouse for boys in San Diego.

"Not one cent has been turned over to Boys Inc. I do not know where the money went," Smith said. "It is my considered opinion that no money will be transferred to Boys Inc. for at least five years, if then. I hope I have given you a fair idea of what I think of Mr. Murchison and Mr. Richardson."

Sid Richardson died in September 1959. John Connally, Richardson's top aide, who would later become governor of Texas and be wounded while riding in the limousine with President John F. Kennedy in the November 22, 1963 assassination, was the co-executor of Richardson's estate. He also replaced Richardson as a member of the racetrack board of directors. Murchison, in ill health, was replaced by his sons John and Clint Jr. For much of the ten-year period starting in 1969, the new Richardson/Murchison leadership group would be entangled in disputes with the State of California and the U.S. Internal Revenue Service, while the total handle at race meetings hovered in the mid-$30 million to low $40 million range and the physical facility, by any account, was mostly neglected.

In 1962, Jim Mills, a freshman assemblyman from San Diego, introduced a bill in the California legislature to prohibit Boys Inc. from renewing its lease on the track, scheduled to expire in 1969, without a public bid process. Governor Pat Brown signed the Mills bill in June 1963, signaling the end of the Texas era at Del Mar, and six years later, when the dust of political infighting had settled, a twenty-year lease was awarded to the Del Mar Thoroughbred Club.

The DMTC was formed in 1968 by a group of California owners, breeders and prominent community members, headed by John C. Mabee and Clement L. Hirsch, whose stated goal was to conduct a first-class race meeting each summer. Although required to be organized as a "for profit" corporation under California Horse Racing Law, the lease agreement ensures that all "profits" generated by its operations are paid in the form of rent to the state through its controlling body on the fairgrounds, the Twenty-second District Agricultural Association, which in turn uses those monies primarily for facility upgrades and maintenance of the grounds. In 1989, when the initial twenty-year lease expired, the DMTC was awarded a second twenty-

Bing Crosby, on Bobtail, established a tradition of top track management on horseback that has been continued by Del Mar Thoroughbred Club CEO Joe Harper. *Courtesy DMTC.*

year lease bidding in competition against John Brunetti, owner of Hialeah Park in Florida and the Ogden-Nederlander entertainment organization. In 2010, when the lease was put up for bid again, the DMTC was the only respondent and was accorded a short-term agreement.

By 1979, ten years after the DMTC takeover, daily average attendance had risen from under 10,000 to 17,449 and daily average handle from under $1 million to over $2.3 million. By 1989, Del Mar had become the country's leading track for daily average attendance and handle and would remain number one or number two, with Saratoga, for decades to come.

Late in 2010, Democratic state senator Christine Kehoe introduced a bill to sell the land occupied by the track and fairgrounds to the City of Del Mar for $120 million. The proposal was quickly met with considerable opposition. If approved, the race meeting would be run by a group headed by prominent owner Mike Pegram, which pledged $30 million for a fifty-year lease and an additional immediate $15 million for improvements to the

facility and stable area to make it suitable as a year-round training facility when live racing is elsewhere.

For every meeting since 1978, Joe Harper has been the man in charge for the DMTC and the public face of Del Mar. The grandson of legendary Hollywood director Cecil B. de Mille, Harper appeared as a child in some of his grandfather's most lavish spectacles, including *The Ten Commandments* and *The Greatest Show on Earth*, and has both fascinating and funny stories of experiences on the sets. A successful Hollywood cinematographer in his twenties and thirties, Harper spent eleven years as an assistant to racetrack cinematographer Joe Burnham before landing a job in racetrack management as executive vice-president of the Oak Tree at Santa Anita meeting from 1971 to 1977 before moving south to Del Mar.

Harper's entertainment industry background and personal style, at least outwardly cool and unflappable like a modern-era Crosby, have served him well in over thirty years as the track's boss. Harper underwent trial by flood in the winter of 1980, when, inspecting a track flooded by heavy rains, he got swept up in a rush of water and carried 220 yards from about the sixteenth pole to the finish line. He supervised the handling of power outages in 1981 and 1983, which cost the track many thousands in lost wagers. He oversaw the institution of aggressive and innovative marketing campaigns to restore lost on-track attendance and revenue with the start of intertrack wagering in 1988 and computer/telephone wagering in 2002, as well as the demolition and reconstruction of the grandstand from 1991 to 1993. He did all of this while appearing to be exactly where he needed to be when he needed to be there—whether that meant on the backstretch early in the morning, sometimes on horseback, for input from horsemen or in the Turf Club or boardroom in the afternoon for input from the high rollers, movers and shakers.

"This isn't the gambling business. It isn't the restaurant business. This is the entertainment business," Harper has said. "Whenever you put forty thousand people into a facility, you better make them happy, and the only way to do that is to entertain them. Whether it's with racing or beautiful people or eleven-dollar margaritas, you have to have them feeling good about being here."

In 1977, Crosby dropped in, as nonchalantly elegant as ever, to pay what turned out to be his last visit to the track he and his Hollywood pals had founded. He died on October 14 of that year of a heart attack on a golf course in Spain.

1937–2010

Common Threads

There are both easy and hard-to-explain reasons why Del Mar has, since its inception, been a special place to those who go there to work, play or both. The easy reasons are its location—in Bing Crosby's words, a "three-wood" away from the ocean—the great horses and horsemen in action there and the opportunity for legal gambling, a horse racing exclusive through most of its first forty years. Harder to explain are the feelings generated by the social comraderie, intentional or unintentional, that can found; the close intermingling of people from all levels of society, from celebrities to commoners; and the fun of participating in rituals, silly or serious, with the masses.

Del Mar has been, and continues to be, a rich source for such things.

BETTING WITH THE STARS

The term "A-list" for celebrities wouldn't be coined for many years, but it seems in retrospect that in its early racing seasons, Del Mar, especially on weekends, was often crawling with those types. Of course, Bing Crosby was one of the biggest stars of the day, as was track co-founder Pat O'Brien, and they created a home away from Hollywood for many of their peers.

Comedian Red Skelton might have been the first, but certainly wasn't the last, to lose his shirt at Del Mar. *Courtesy DMTC.*

On Opening Day in 1937, there was a party, which began on the special train that left Union Station and pulled into the grounds just before post time. It continued after the races and lasted until dawn. Every Saturday night, Crosby himself would preside over festivities that included many of his celebrated friends and always ended with Bing himself at the microphone, accompanied by John Scott Trotter's Sidemen, singing until the wee hours.

The press parties were legendary and survived beyond the Crosby years. George Jessel emceed many of them, and entertainers like Al Jolson, O'Brien, Danny Thomas, Joe Frisco, Abe Burrows, the Ritz Brothers, Tony Martin and Donald O'Connor performed at them. Visits by Bob Hope during the Crosby years and the impromptu performances they put on together reportedly inspired them to collaborate professionally on their series of celebrated "Road" pictures.

Jimmy Durante, for whom the track's turf course would later be named, was a regular on the scene and often climaxed his contributions by dismantling

A winner is right under Jimmy Durante's iconic nose during one of his frequent appearances at the track. The turf course and a main thoroughfare at Del Mar now bear his name. *Courtesy DMTC.*

a trick piano as part of his act. One year, operations manager Bud Brubaker recalled, Durante forgot to bring his own piano and attacked a rented upright that he proceeded to demolish with gusto, hurling bits and pieces of the instrument over the Turf Club railing to the patio twenty-five feet below. The track bought the piano. On another occasion, in 1948, Al Jolson became so exasperated by O'Brien's needling regarding his advanced age that he suddenly barked, "You ain't seen nothin' yet!" and proceeded to tear the tablecloth out

Comedian W.C. Fields ponders the day's card on a visit to the track in 1940. *Courtesy DMTC.*

from under a huge setting, sending glasses and plates flying. He then jumped about four feet from a standing position onto the table and started to tap dance.

Name a major entertainment personality from the '30s, '40s and '50s and chances are the Del Mar Thoroughbred Club has a picture of him or her at the track in the archives. To name a few: Gloria Swanson, W.C. Fields, Edward G. Robinson, Red Skelton, Jackie Cooper, Mickey Rooney, Joan Blondell, Dick Powell, George Raft, Ava Gardner, Don Ameche, Lucille Ball and Desi Arnaz, Ann Sheridan, Paulette Goddard, William Bendix, Ken Murray, Barbara Stanwyck, Robert Taylor and Dorothy Lamour. The list goes on and on.

Bandleader Harry James and his wife, Betty Grable, were regulars, and James's horse Big Noise won the 1951 Futurity. Twenty-four years later, Telly's Pop, co-owned by actor Telly "Who loves ya baby?" Savalas would take the top two-year-old race, and in 2005, Stevie Wonderboy, owned by entertainment mogul Merv Griffin and named for musician Stevie Wonder, was the Futurity champion.

Predictably, maintaining such a strong Hollywood connection proved impossible post-Crosby. And the decline in racing's ranking among popular sports over the decades made Del Mar, like other tracks, less of a place for celebrities to

During the *I Love Lucy* era, Lucille Ball and Desi Arnaz were frequent visitors and raced their own horses at Del Mar. Desi later retired to a beachfront home at Del Mar. *Courtesy DMTC.*

see and be seen than it had been in the early years. While "A-listers" have become something of a rarity, Del Mar hasn't been abandoned by genuine stars and has been visited in recent years by Kevin Costner, Tobey Maguire, Uma Thurman, Luke Wilson, Gwen Stefani and the entire crew of *Entourage*. The track has also taken advantage of the expansion of the "celebrity" category in recent years, and on most any racing day—especially weekends—big-name sports, reality or cable TV personalities and the like can usually be found handing out the trophy and posing with the horses and winning connections of the feature race.

Keeping the Crosby-established tradition for musical entertainment and a party atmosphere has proven easier and, in fact, economically vital. A series of post-race concerts has been established, with regular Friday Night events at a stage behind the grandstand generally featuring local artists.

Track officials, accustomed to the Friday events drawing crowds in the fifteen to seventeen thousand range, were unaware of what they were getting when they booked singer Jack Johnson and had around thirty thousand fans show up. "Thank goodness he's a mellow dude and drew a mellow crowd or we could have been in trouble," one official said. Johnson, who was paid

Above: A star power trio frequently seen at the track: America's toastmaster General George Jessel, bandleader Harry James and James's wife, Betty Grable. *Courtesy DMTC.*

Below: Ava Gardner enjoyed a day at the races with her sister, Beatrice. *Courtesy DMTC.*

Track founder Pat O'Brien shares a Turf Club moment with Don Ameche. *Courtesy DMTC.*

$10,000, left with high praise for the whole scene and was keen to come back another time. But a chart-topping album and other successes skyrocketed his profile and priced him out of Del Mar's range. Besides Johnson, other Friday favorites among Del Mar crowds have been Cake, Violent Femmes, Jason Mraz, G-Love and Special Sauce and The B-52s.

Two or three events a meeting are also scheduled on the infield stage and have featured groups like Gnarls Barkley, Devo, Weezer, Ziggy Marley, Billy Idol and ZZ Top, enticing crowds tens of thousands strong to stay after the races and into the night.

WHERE THE TURF MEETS THE SURF

Besides the Seabiscuit-Ligaroti match race, 1938 was the year of the song for Del Mar that remains probably the most famous racetrack ditty ever penned.

DEL MAR

The wife of one of Bing Crosby's writers thought up the phrase "Where the turf meets the surf," but Crosby himself and Johnny Burke collaborated on the rest of the lyrics, which were set to music by James V. Monaco.

Few people have ever heard the verse:

> *Some people dream of moonlight on the Ganges.*
> *Some dream of where the River Shannon flows.*
> *While others long to be on the Isle of Capri,*
> *And some long for a Nagasaki Rose.*
> *Some hope to see Samoa of Samoa,*
> *or Bali Bali or Old Avalon.*
> *But anywhere you please,*
> *Ask the travel agencies,*
> *There's one place that they'll all agree upon.*

Around Del Mar, however, the chorus is as well known as that of our national anthem, and it's a lot easier to sing:

> *Where the turf meets the surf,*
> *Down at Old Del Mar.*
> *Take a plane, take a train, take a car.*
> *There's a smile on every face,*
> *And a winner in each race,*
> *Where the turf meets the surf at Del Mar.*

Crosby sang it live in 1938, and the recording he made of it is still played before the first race and after the last race of every program. In 2005, the marketing department came up with a "Sing with Bing" idea in which someone would be invited to the winner's circle between races to sing the chorus over the public address system—sort of Del Mar's version of the Wrigley Field tradition of "Take Me Out to the Ball Game" for the seventh-inning stretch, but without the crowd participation. It was nearly DOA when the duet of Chargers quarterback Drew Brees and ESPN broadcaster Kenny Mayne totally butchered the inaugural rendition. But it survived, with a few presentational tweaks, and looks likely to be a tradition for years to come.

Track radio and television advertising campaigns in recent years have featured versions of "Where the Turf Meets the Surf" done '60s, '70s, '80s and even more contemporary styles. The song, like the track it celebrates, stood up well through the decades.

Sources

PROLOGUE

San Diego Union-Tribune, August 11–13, 2010.

ZENYATTA 1-2-3

San Diego Union-Tribune, August 3, 2008; August 10, 2009; August 8, 2010.

CHANGES ON THE SURFACE

San Diego Union-Tribune, February 1, 2007; July 15, 19, 31, 2007; July 22, 30, 2009.

THE DARK SIDE

San Diego Union-Tribune, July 30, 1998; August 13–14, 1998; July 20, 22, 27, 2006; September 6, 2006.

THE MAGICAL MEETING OF 2003

San Diego Union-Tribune, July 24, 2003; August 21, 24, 2003; September 10–11, 2003.

Sources

Azeri 1-2

San Diego Union-Tribune, August 10, 2002; August 10–11, 2003; August 12, 2010.

What about Bob Baffert?

San Diego Union-Tribune, July 23, 2002; August 4, 26, 2002; August 12, 2009; September 8, 2009.

Bobby Frankel, from Claimers to Classics

San Diego Union-Tribune, August 18, 2001; November 17, 21, 2009.

PVal, Mr. Comeback

San Diego Union-Tribune, July 28, 2002; September 6, 8, 10, 2003; July 3, 2004; July 29–August 1, 2004; August 6, 2004; July 20, 29, 2010

No Cigar

San Diego Union-Tribune, August 10, 2006.

Glory Days for the Home Team

San Diego Union, August 11, 1991.
San Diego Union-Tribune, August 30, 1999; August 11, 2010.

Everybody's Best Pal

San Diego Union-Tribune, March 13, 1999; August 11, 2010.

The Walls Come Down

Murray, William. *Del Mar, Its Life and Good Times.* Del Mar, CA: Del Mar Thoroughbred Club, 1988.
San Diego Union; September 11, 1991.

CHRIS MCCARRON

San Diego Union-Tribune, June 24, 2002.

LAFFIT PINCAY JR.

San Diego Union-Tribune, August 20, 23, 2002; September 1, 2003.

EDDIE DELAHOUSSAYE

San Diego Union, September 14, 1989; July 23, 1990.
San Diego Union-Tribune, August 14, 1994; January 18, 2003.

GARY STEVENS

San Diego Union-Tribune, September 1, 2002; September 3, 2004.

CHARLIE WHITTINGHAM

San Diego Union, May 4, 1986.
San Diego Union-Tribune, April 20, 1999; August 1, 1999.

D. WAYNE LUKAS

San Diego Union, July 25, 1989.

RON MCANALLY

San Diego Union, July 23, 1990.
San Diego Union-Tribune, August 11, 2004.

THE 1950S–1970S

Washington Racing Hall of Fame. R.H. McDaniel biography, n.d.

THE PUMPER AND THE SHOE

San Diego Union, September 11, 1989.

FARRELL JONES

San Diego Union-Tribune, July 23, 2003.

HOLLYWOOD BEGINNING

Murray, William. *Del Mar, Its Life and Good Times.* Del Mar, CA: Del Mar Thoroughbred Club, 1988.

PUTTING DEL MAR ON THE MAP

Murray, William. *Del Mar, Its Life and Good Times.* Del Mar, CA: Del Mar Thoroughbred Club, 1988.
San Diego Union, August 18, 1938.
San Diego Union-Tribune, August 18, 2003.

PRE- AND POSTWAR

Murray, William. *Del Mar, Its Life and Good Times.* Del Mar, CA: Del Mar Thoroughbred Club, 1988.

TRACK MANAGEMENT, FROM BING TO JOE

Murray, William. *Del Mar, Its Life and Good Times.* Del Mar, CA: Del Mar Thoroughbred Club, 1988.
San Diego Reader, January 6, 13, 2011.
San Diego Union-Tribune, August 15, 2007.

BETTING WITH THE STARS

Murray, William. *Del Mar, Its Life and Good Times.* Del Mar, CA: Del Mar Thoroughbred Club, 1988.
San Diego Union-Tribune, July 27, 2005.

Index

About the Author

Hank Wesch completed a nearly fifty-year career as a newspaper sportswriter with his retirement in September 2010. The last thirty-six years of that career were spent at the *San Diego Union-Tribune*, where his assignments included covering horse racing—and the Del Mar summer thoroughbred race meeting, specifically—starting in 1985. He has been published in several newspapers and magazines, but this is his first book project.

Courtesy San Diego Union-Tribune

Visit us at
www.historypress.net